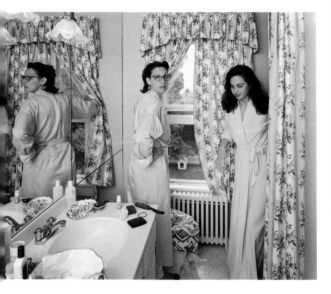

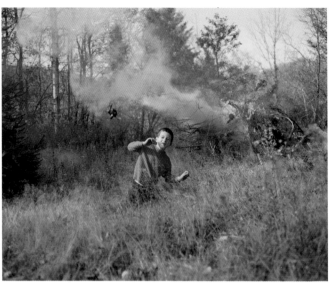

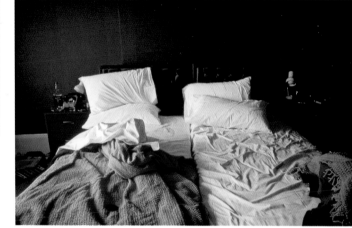

so the story **goes**

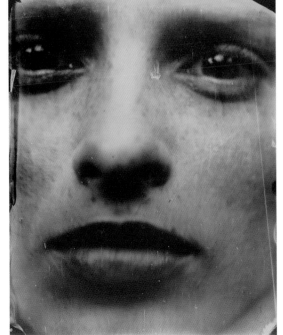

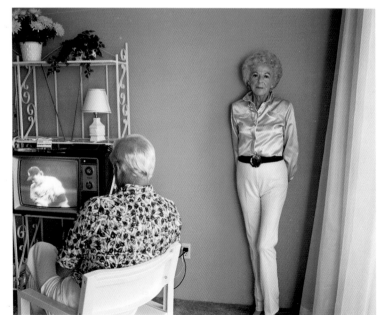

Katherine A. Bussard

The Art Institute of Chicago
Yale University Press, New Haven and London

so the story goes

photographs by

tina **barney**

philip-lorca **dicorcia**

nan **goldin**

sally **mann**

larry **sultan**

So the Story Goes: Photographs by Tina Barney, Philip-Lorca diCorcia, Nan Goldin, Sally Mann, and Larry Sultan has been published in conjunction with an exhibition presented at the Art Institute of Chicago from September 16 to December 3, 2006.

This exhibition was organized by the Art Institute of Chicago. This exhibition is made possible by the Evening Associates of the Art Institute of Chicago.

Additional funding is provided by the Robert Mapplethorpe Foundation, Inc.

First edition
Printed in Italy
Library of Congress Control Number: 2006926776
ISBN 13: 978-0-300-11411-9
ISBN 10: 0-300-11411-7

2 00 6 002 556

Published by
The Art Institute of Chicago
111 South Michigan Avenue
Chicago, Illinois 60603-6404
www.artic.edu

Distributed by
Yale University Press
302 Temple Street
P.O. Box 209040
New Haven, Connecticut 06520-9040
www.yalebooks.com

Produced by the Publications Department of the Art Institute of Chicago, Susan F. Rossen, Executive Director

Edited by Elizabeth Stepina, Project Editor
Production by Amanda W. Freymann, Publications Consultant
Image rights clearance by Sarah K. Hoadley, Photography Editor

Designed and typeset by Karin Kuzniar, Department of Graphic Design, Photographic, and Communication Services
Separations by Professional Graphics, Rockford, Illinois
Printing and binding by Mondadori Printing, S.p.A., Verona, Italy

Artists' biographies on pp. 120–21, 123–24, 126 authored by Gregory Harris, Intern, Department of Photography

Front cover (clockwise from upper left):
Tina Barney, *Jill and Polly in the Bathroom* (detail), 1987 (see pp. 22, 120)
Philip-Lorca diCorcia, *DeBruce* (detail), 1999 (see pp. 53, 122)
Nan Goldin, *Empty beds, Lexington, Massachusetts* (detail), 1979 (see pp. 60, 123)
Larry Sultan, *Mom Posing for Me* (detail), 1984 (see pp. 115, 126)
Sally Mann, *Triptych* (detail of *Virginia*), 2004 (see pp. 97, 126)

table of **contents**

Sponsor's Statement, Andrea M. Moran 6

Director's Foreword, James Cuno 7

Personal Stories, Public Pictures, Katherine A. Bussard 8

Portfolio

 tina **barney** 18

 philip-lorca **dicorcia** 38

 nan **goldin** 58

 sally **mann** 78

 larry **sultan** 98

Notes 118

Exhibition Catalogue 120

Acknowledgments 128

sponsor's statement

The Evening Associates Board, an auxiliary group of the Art Institute of Chicago, is proud to celebrate the work of Tina Barney, Philip-Lorca diCorcia, Nan Goldin, Sally Mann, and Larry Sultan through its sponsorship of the exhibition *So the Story Goes*. The exhibition and catalogue bring together over 150 works, all of which explore the complex and varied ways that photographs can tell a life's story. Recording their own experiences, environments, friends, and families, these five contemporary photographers have invited the audience into their own private realities. In their hands, everyday subjects become both strange and familiar; intimate moments are both romantic and sad. We hope these works inspire viewers to reflect on their own experiences, emotions, and circumstances.

The mission of the Evening Associates Board is to provide and support innovative art-related programs and events for young professional Art Institute members and the general public. We would like to thank many people at the museum, especially President and Eloise W. Martin Director James Cuno, Assistant Curator of Photography Katherine A. Bussard, and the entire Photography Department, for bringing this exciting exhibition to life. It has been a joy working with them in preparation for this great event.

Enjoy.

Andrea M. Moran
Chairman of the Evening Associates Board
The Art Institute of Chicago

director's foreword

Photography has always been concerned with the intimacies of life: sometimes in the form of the casual snapshot—a birthday party, lost tooth, new pet, or old friend; sometimes, in a more formal composition—a high school graduation, wedding, anniversary, or birth. The five photographers represented in *So the Story Goes* have taken the subjects of their lives as their inspiration: the stuff of self-conscious—and *self-revealing*—art making.

Tina Barney possesses a sureness of color, composition, and psychological sensitivity. Her photographs seem to capture both her specific, personal relationships and the general social relations of affluent East Coast life. Larry Sultan has created a project that feels particularly generational, photographing the retired, suburban life of his parents after the corporate boom of the 1980s. Almost incessantly, Nan Goldin chronicles her life, capturing intensely private moments with an acute aesthetic sensitivity. Sally Mann's photographs are perhaps even more personal, emphasizing her physical proximity to and immediacy of feelings for her subjects, both family and place. Among the more ambiguous images presented here, Philip-Lorca diCorcia's works suggest a personal narrative but never reveal one, prompting viewers to make their own assumptions on the meaning of his works.

Through technique, presentation, and content, these five photographers all elevate the aesthetics of personal photography. We are especially grateful to Katherine A. Bussard, Assistant Curator of Photography, for proposing and curating this exhibition, and to the Committee on Photography for supporting *So the Story Goes*, as well as the many acquisitions made in conjunction with it.

James Cuno
President and Eloise W. Martin Director
The Art Institute of Chicago

personal stories
public **pictures**

Katherine A. Bussard

And the life that you live in order to photograph it is already, at the outset, a commemoration of itself. —Italo Calvino[1]

Take one picture and stop time, preserve the moment. Take enough pictures over enough time, however, and they may eventually shape, perhaps even transform, the way life is lived and commemorated. Since its introduction, photography has always been considered the perfect medium for recording one's life. From amateur snapshots taken throughout the twentieth century with mass-marketed cameras to today's digital photographs that can be viewed and shared instantly, photography has continually provided a way for people to tell their story. This is no less true for artists who have used their own personal experiences as their inspiration.

The five contemporary photographers featured in *So the Story Goes*—Tina Barney, Philip-Lorca diCorcia, Nan Goldin, Sally Mann, and Larry Sultan—offer us glimpses into their own private realities. Just as no two people keep the same diary, each of these photographers has created highly personal, intriguing, and shifting visions that explore the nature of personal events, memories, and identities. More importantly, they have shaped their particular photographic stories as they want them to be seen by an audience outside of their friends or relatives, thus raising questions about how we as viewers relate not only to their photographs but to our own. We cherish our own photographs for their ability to transport us to a moment in the past, to reassure us of that moment's existence, to prompt us to tell the story surrounding it, and to stave off the eventual loss of its memory. Tethering us in the present to our past and linking our present moments to future recall, personal photos also inevitably connect to a broader cultural moment, since they engage with received histories and ideologies about how life is to be lived and, perhaps more durably, how it is to be represented by and remembered through photographs.

The personal images of Barney, diCorcia, Goldin, Mann, and Sultan share their subject matter with a group of earlier photographic practices, both vernacular and artistic. Indeed, within months of the public declaration of the medium's invention, enthusiasts seized upon the possibility of recording the image of a loved one in a photographic portrait.[2] "I long to have such a memorial of every being dear to me in the world," wrote Elizabeth Barrett in 1843. "It is not merely the likeness

which is precious in such cases—but the association and the sense of nearness involved in the thing. . . the fact of the very shadow of the person lying there fixed forever!"[3] Aiming to capture a physical likeness, these early photographs reflect age-old conventions of portraiture.[4] In the next decade, as the cost of making photographs fell, customers were more able to return to the photographer's studio to capture a different age or to commemorate a special occasion. And so people began to conceive of documenting not just their likenesses, but their entire lives in photographs.

A truly personal photograph, divorced from the studio, became fully possible with the invention of snapshot photography. In 1888 George Eastman debuted the Kodak #1: a box camera with a basic lens that was preloaded with a roll of film which would yield one hundred small photographs. Eastman's slogan—"You press the button, we do the rest"—was all one needed to know. Anyone who wanted to make a photograph simply pointed the camera at a desired subject or scene, pushed the button, sent the camera back to the company, and soon after enjoyed seeing photographic prints along with a fully reloaded camera, ready to take more snapshots. Box cameras quickly became accessible to many; the successor to the Kodak #1, the Brownie, was introduced in 1900 at the relatively affordable rate of a single dollar, the equivalent of approximately twenty-two dollars today.[5] This next generation of point-and-shoot cameras created an unprecedented level of democratization in photographic practice.

Moreover, these small, portable box cameras allowed amateurs to make photographs where and when they liked (see fig. 2). This flexibility quickly yielded images far removed from the formal conventions of the commercial studio portrait, capturing instead the casual, accidental, and incidental qualities of life both in- and out-of-doors (see fig. 1). The ability to photograph both in public and private, and to capture subjects both self-aware and unaware, dramatically affected not just the look of the photographs but, more broadly, the narratives they suggested. As photography historian Douglas Nickel has noted, "The means by which people regarded their own histories also changed; the way lives were lived became entangled in the way lives were now represented."[6] Because everyday people could take, share, and archive personal snapshots, photographers and their subjects alike began to understand that they could shape—even determine—how an occasion would come to be recalled visually, how the story of that moment would be evoked through pictures.

What had emerged as a hastily made photograph, shot from the hip—as the word "snapshot" originally denoted—in time became a highly standardized image.[7] In snapshots taken "correctly," subjects are

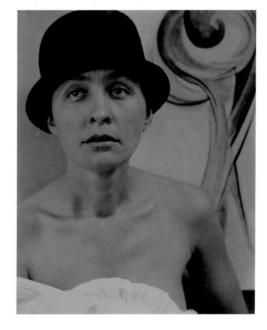

Fig. 3. Alfred Stieglitz. American, 1864-1946. *Georgia O'Keeffe*, 1918. Palladium print; 25.4 x 20.3 cm (10 x 8 in.). The Art Institute of Chicago, Alfred Stieglitz Collection, 1949.750.

centered in the composition and face the camera directly, with requisite—and often commanded—smiles. For more than a century, such notions about what makes a good snapshot have shifted little.[8] In fact, cameras sold today offer templates that appear in the viewfinder to aid in the composing and taking of such correct individual and group photographs. Now a formulaic and static mode of representation, the snapshot engages in dominant, socially approved mythologies of a so-called normal life. As the French sociologist Pierre Bourdieu observed in his study of photographic habits, "Nothing *may* be photographed apart from that which *must* be photographed. The ceremony may be photographed because it is outside of the daily routine, and must be photographed because it realizes the image that the group seeks to give of itself as a group."[9] Personal snapshot

photography could thus be understood as confirming, even extending, the collective significance attached to certain social roles within the broader culture, both at the moment of taking a photograph and in later, repeated viewings of it.

Long before snapshots became formally and socially conventionalized, artists, too, were interested in commemorating their lives with photography. In fact, it had become increasingly important that photographers who wanted their creations to be taken seriously *as art* differentiate their work from anything resembling popular photography. In this context, photographer and art dealer Alfred Stieglitz formulated a specifically modern notion of artistic portraiture. Believing that only multiple photographs—showing all stages of life and every manner of pose, mood, and dress—could truly represent an individual, he embarked on a study of his lover and future wife, Georgia O'Keeffe.[10] In his series *Georgia O'Keeffe: A Portrait* (1921–37), Stieglitz presented a range of pictures: in some, only her expressive hands fill the photographic frame; in close-ups of her nude torso, she appears as an erotic object; and in others she is posed confidently before her own paintings. The work illustrated here (fig. 3) combines these sentiments and signals a

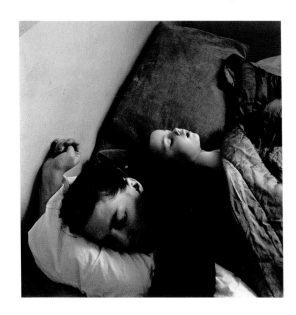

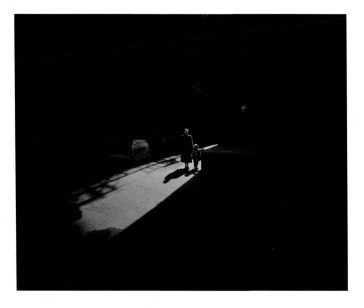

Fig. 4. Harry Callahan. American, 1912–1999. *Eleanor and Barbara, Chicago*, c. 1955. Gelatin silver print; 17.2 x 16.7 cm (6 3/4 x 6 9/16 in.). The Art Institute of Chicago, The Sandor Family Collection in honor of the School of the Art Institute of Chicago, 1994.849.

Fig. 5. Harry Callahan. American, 1912–1999. *Untitled*, 1953. Gelatin silver print, dry-mounted on board; 19.5 x 24.4 cm (7 11/16 x 9 9/16 in.). The Art Institute of Chicago, The Sandor Family Collection in honor of the School of the Art Institute of Chicago, 1994.866.

declarative break with the day's more formal photographic approach. The play between frank sexuality and appropriate dress declares the physical as well as emotional closeness of photographer and sitter. Stieglitz's philosophical vision of how to intimately portray O'Keeffe provides an early, compelling artistic precedent for the work in this exhibition.

A generation later, Harry Callahan also aspired to create photographs of his wife, Eleanor, that would stand apart for their artistry—be it through composition, collaboration, or concept.[11] When their daughter, Barbara, was born in 1950, she joined Eleanor in the photographs as well (see fig. 4). In these timeless works, the pair often appear in simple, nondescript settings; neither style of dress, décor, nor other details reveal the date of the images. Callahan soon realized that some of these pictures effectively combined the studied, formal qualities of compositions that a large-format view camera and tripod produce with the casual, more momentary characteristics of the "correct" snapshot photograph (see fig. 5). To make these 8 x 10 snapshots, as Callahan called them, he used available outdoor light and presented the subjects centered in the frame, facing the photographer. Scholar Britt Salvesen has identified the

development of these images not as a regression to a less skilled technique, but as an appropriation of certain aspects of the snapshot aesthetic.[12]

Large-scale recognition of the genre of personal photography came following World War II in the influential exhibition *The Family of Man*. Curated by Edward Steichen, the enormously popular show opened at the Museum of Modern Art, New York, in 1955 and toured to sixty-nine international venues, amassing a viewership of over nine million people. *The Family of Man* included over five hundred pictures—culled from artists, journalists, amateurs, collections, and publishers' files—all of which were presented without differentiation in a sequence charting allegedly universal life experiences: coupling, childhood, family, work, play, and death.[13] Divorced from their original meaning and intention, the photographs were subsumed by the exhibition's humanist

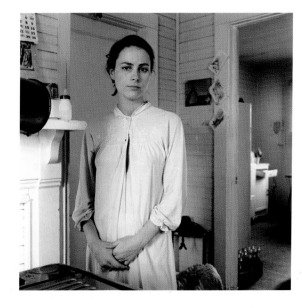

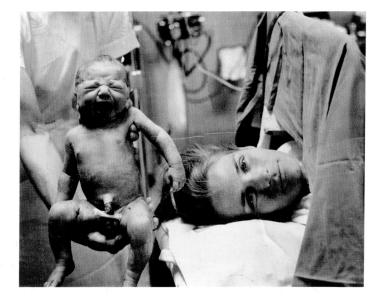

Fig. 6. Emmet Gowin. American, born 1941. *Edith, Danville, Virginia*, 1967. Gelatin silver print; 14.8 x 14.9 cm (5 13/16 x 5 7/8 in.). The Art Institute of Chicago, gift of David and Reva Logan, 1991.1121.

Fig. 7. Emmet Gowin. American, born 1941. *Untitled*, 1969. Gelatin silver print; 11.2 x 14.8 cm (4 2/8 x 5 13/16 in.). The Art Institute of Chicago, gift of Arnold Gilbert, 1981.1115.

agenda. In this way, *The Family of Man* marks an early and significant conflation of the quotidian snapshot and the artistic endeavor.

In the 1960s and 1970s, the idea of using photography as a vehicle of personal experience would engage a group of formally trained photographers—most notably Emmet Gowin, Lee Friedlander, and Nicholas Nixon. Gowin, for example, sought to unite the impact of Stieglitz's attention to symbol, Callahan's acceptance of one's relations as important and worthy subjects, and the immediacy of feeling in the works featured in *The Family of Man*. Gowin admitted, "I was wandering about in the world looking for an interesting place to be, when I realized that where I was was already interesting,"[14] which led him to begin photographing his wife, Edith, and her extended family in their hometown of Danville, Virginia (see figs. 6–7). Friedlander also took

to photographing his relationship with his wife, Maria, and later with their two young children. Using his favorite equipment, a handheld 35-millimeter camera, he reveled in recording the most ordinary of moments, not just family outings or holidays. Some, such as the photograph of Maria nude in a space strongly patterned by sunlight, replicate what would come to be known as Friedlander's characteristic self-portrait, in which his own shadow is cast on his subject (see fig. 8). In 1975 Nixon began an ongoing, annual series of portraits of his wife, Bebe Brown Nixon, and her three sisters (see figs. 9–10). Notably, he did so with an 8 x 10-inch view camera, which yielded photographs with the utmost level of detail and a heightened sense of reality. For Nixon, in these photographs, "You can see everything. It creates the illusion of being able to see more than the eye could see if you were there."[15] Like Callahan before him, Nixon combined the spontaneous agility of snapshots with the considered approach that a view camera requires.

By the time the generation of Gowin, Friedlander, and Nixon had come into its own, enough photographers were pursuing personal subject matter that creating an exhibition on the topic no longer required the amateur component that Steichen had worked so hard to integrate into *The Family of Man*. The 1991 exhibition *Pleasures and Terrors of Domestic Comfort*, also organized by the Museum of Modern Art, surveyed work created since 1980 by over sixty artists, including Nixon and Friedlander, as well as the five photographers featured in *So the Story Goes*.[16] In the show and catalogue, curator Peter Galassi charted a dramatic and decisive shift in the medium's subject matter.

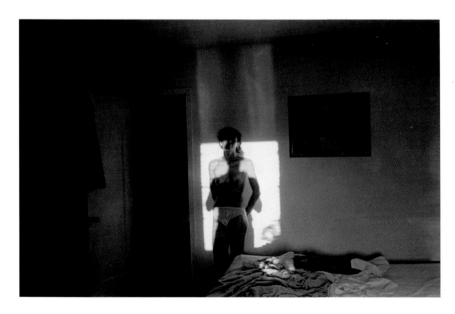

Fig. 8. Lee Friedlander. American, born 1934. *Maria Friedlander, Las Vegas, Nevada*, 1970. Gelatin silver print; 27.9 x 35.6 cm (11 x 14 in.). Courtesy of Janet Borden, Inc.

Street photography, understood to have had its heyday in the preceding two decades, had now been eclipsed by domestic photography as the dominant means of expression for photographers. *Pleasures and Terrors* declared a definitive transition from public subjects to private ones, from a commitment to facts to an engagement with fiction, and a turn from outdoor to indoor photographic practice.

In comparing the work of Gowin, Friedlander, and Nixon to that of the following generation, a crucial, yet subtle change becomes apparent. In part, this shift could be characterized as one of technique and subject matter. Whereas Gowin, Friedlander, and Nixon made black-and-white photographs of their wives and children and produced modestly sized prints that rarely exceed eight by ten inches, younger photographers were creating large-scale color photographs of an ever-expanding notion of family and loved ones. The effect of the latter was anything but merely procedural; these larger prints, ranging from twenty by twenty-four inches up to four by five feet, diminished all sense of preciousness and enveloped the viewer in the scene. Moreover, the strong color present in so much of this work heightened its emotional impact, and the more encompassing subject matter created a wider umbrella for who is considered family, only increasing the appeal of an already relatable subject.

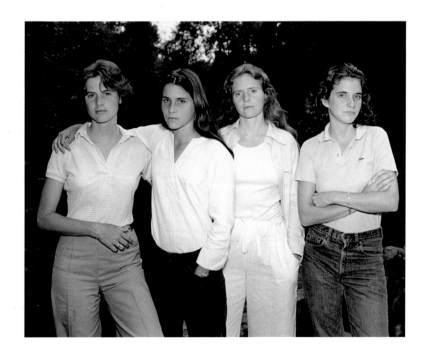

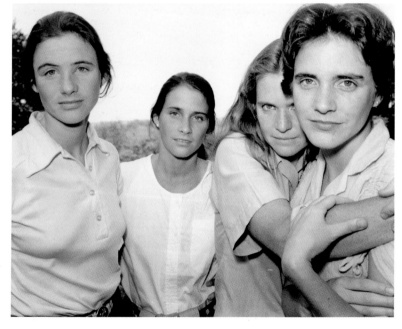

Fig. 9. Nicholas Nixon. American, born 1947. *Heather Brown McCann, Mimi Brown, Bebe Brown Nixon, Laurie Brown, New Canaan, Conn.*, 1975. Gelatin silver print; 19.5 x 24.6 cm (7 11/16 x 9 11/16 in.). The Art Institute of Chicago, gift of Nicholas Nixon, 1985.224.

Fig. 10. Nicholas Nixon. American, born 1947. *Heather Brown, Mimi Brown, Bebe Brown Nixon, Laurie Brown Travchin, E. Greenwich, R.I.*, 1980. Gelatin silver print; 19.5 x 24.5 cm (7 11/16 x 9 5/8 in.). The Art Institute of Chicago, gift of Nicholas Nixon, 1985.225.

These younger photographers also began to challenge the inherent believability of photography as a medium, through image presentation, content, and editing. A new generation—led by the five photographers featured in *So the Story* Goes—was creating works that were no longer predictably straightforward and celebratory (like the personal snapshot), artful records of an intimate relationship (like Stieglitz's *Portrait*), or even a mixture of the two (like Callahan's and Nixon's photographs). We might say that Barney, diCorcia, Goldin, Mann, and Sultan have interrupted such conventions, scrutinized them with their cameras, and extracted the awkward and discomforting moments known to be lurking just beneath their surfaces. Their photographs rupture the long-held notion of opposing extremes in photography: fact and fiction, documentary and directorial, window to the outside world and mirror onto oneself. In doing so, these photographers promote a more critical, subjective evaluation of personal photography—one that is inherently reliant on the experiences of the viewer, both what they bring to the work and what they take from it.

Tina Barney spent fifteen years photographing her family and friends in their affluent surroundings (see pp. 18–37). Despite her subjects' apparently natural poses and expressions, these photographs are not moments casually observed, but rather carefully orchestrated by Barney. Philip-Lorca diCorcia selected photographs of his life made over a period of more than twenty years, sequencing them to create a highly personal and idiosyncratic narrative, which he titled *A Storybook Life* (see pp. 38–57). The problem of how we make sense of these pictures, imagining diCorcia's experiences based on the precarious logic connecting the images themselves, is at the heart of this project. For more than three decades, Nan Goldin's photographs have unabashedly embraced the intensity of her experiences, documenting even the messiest of emotions and most troubling of events (see pp. 58–77). For her, the photographs constitute a long, frank, and detailed look at her life. For us, they serve as a reminder of the many situations we may omit from our own personal photographs. Sally Mann turned to the world of her children in the late 1980s and early 1990s, making photographs that challenge our assumptions about childhood and innocence. Her newest work, by contrast, depicts her children's mature faces in views that formally and conceptually reflect on the fugitive quality of life at any age (see pp. 78–97). Larry Sultan collaborated with his parents, photographing them in the post-corporate, retirement phase of their lives while at the same time appropriating old family snapshots and repurposing their home videos (see pp. 98–117). In doing so, his project *Pictures from Home* critically extends and revises his parents' story of their relationship as well as notions of family.

These five photographers began the work described above within roughly five years of one another in the early 1980s. Almost all of them remained preoccupied by the same project over the next decade.

Thus, a shared cultural moment marks the making of their photographs. Barney, diCorcia, Goldin, Mann, and Sultan created images that refute the typical domestic scenes of the day, exemplified in popular culture by television shows such as *Family Ties, Growing Pains,* and *The Cosby Show*. Even Barney, whose photographs seem to record a more traditional family situation, made certain to expose the tension inherent in her view of that life. When capturing a strained moment between mother and daughter, Barney moved in close, foregrounding the daughter's gesture of spinning her ring and their glances that do not seem to meet, and in so doing made the evidence of familial tension inescapable (see p. 30). Crucially, the Reagan era's veneration of so-called "family values" either hoped to ignore or intended to undermine the increasingly divergent experiences of family: rising divorce rates, more single-parent households, raging debates over abortion and birth control, and a gay community redefining itself in the face of the AIDS crisis. This context explicitly informed Sultan's *Pictures from Home*: "These were the Reagan years, when the image and the institution of family were being used as an inspirational symbol by resurgent conservatives. I wanted to puncture this mythology of the family and to show what happens when we are driven by images of success. And I was willing to use my family to prove a point."[17] Goldin's work advanced a notion of family that went far beyond the traditional, biological unit espoused by the politics of the era to encompass her friends and lovers, many of whom led lives that fell outside the social norm, involving addiction, crossdressing, and bisexuality.

Part of what sets Barney, diCorcia, Goldin, Mann, and Sultan apart—the hallmark of their appropriateness to our time—is their ability to locate the profoundly extraordinary lurking within everyday personal occurrences. They photograph the very events, sights, and emotions that are purposefully excluded from our own personal snapshots or which were previously deemed inappropriate for aesthetic consideration. These five photographers choose to focus their attention on an anxious look, a loved one's funeral, an unmade bed, a protective caress, or an argument in progress.[18] In Goldin's portrayal of an empty, rumpled bed (see p. 60), we may be reminded of the ephemeral quality of everyday life, an aching for the intimacy the bed suggests, or the absence created by lost love. If childhood seems to be a common subject matter, the moments Mann chose to isolate and preserve are not those typically photographed, as in her seemingly ominous picture of her son's naked torso caked with popsicle drips (p. 82). Expanding the definition of the personal photograph, Barney, diCorcia, Goldin, Mann, and Sultan allow us to see more, and not just because of a heightened level of disclosure. There are more moments captured and their poignancy to be considered, more emotions conveyed and their effects to be negotiated, more stories discerned and their interpretations to be imagined.

Every one of these raised stakes further engages viewers in the work. Indeed, the five photographers featured in *So the Story Goes* rely on the critical, subjective, and psychological reactions of their audience. Of the group, arguably Sultan most explicitly orchestrates this interaction between viewers and his work by including in his project narrative

texts—authored by himself, his father, or mother. These texts, appearing alongside the pictures, act as layered voices that both enrich his narrative and also directly address the viewer. DiCorcia, conversely, more subtly exposes the exchange between audience and photographer. Devoid of personal information, save for date and location, the photographs in *A Storybook Life* construct their narratives and thus their meanings through the sequence assigned by diCorcia and, in turn, the viewer's response to it. This mode of relating to the pictures capitalizes on photography's unique emotional power, at once intensely personal and unavoidably common, a theme taken up by the writer Roland Barthes in his seminal text *Camera Lucida*.[19] Barthes embraced the extremely relatable quality of photography, for its matchless ability to get under our skin, to stay with us, to "prick" us. His attention to how we normally see photos of the people and places we are attached to reminds us how deeply, for each viewer, this seeing is always already affected by what we bring to the photos. Barthes, however, maintained a distinction between our responses to photographs when looking at images circulating in culture, on the one hand, and our own personal photographs, on the other.[20]

But what if the images made by others of their experiences relate to and conjure our own photographs and experiences, even to such a degree that in their photographed lives we see our own? An answer may be found when we view the photographs of *So the Story Goes*. As private images presented in a public context, these works by Barney, diCorcia, Goldin, Mann, and Sultan encourage highly affected

and emotionally powerful forms of looking. When many and varied viewers engage—potentially multiple times—such highly relatable images, new narratives emerge. In their photographs, we may see something of ourselves, our loved ones, their expressions, or a memorable vacation. All the while, our own subjectivity keeps us aware of their strangeness to us, of the slipperiness of such illusions of similarity. Potentially, ideally even, this encounter also contains an invitation for us to reconsider the narratives suggested by our own personal photographs. Perhaps such personal images are never as private or individual as they seem once we recognize the very public and collective nature of our notions of self, family, childhood, relationships, and even place and time.

tina barney

Tina Barney has said, "I began photographing what I knew."[1] For much of the 1980s and 1990s, this meant taking pictures of her friends and family as they went about their daily lives in affluent East Coast settings. Employing large-format view cameras enabled her to create highly detailed images that retain their focus and richness even when made into four-by-five-foot prints. Barney was thus one of the first photographers to present color work on a grand scale that rivaled most twentieth-century paintings. This shift in technique also inspired a deliberate construction of the picture, at times requiring supplementary lighting and the direction of the sitters.

Her sitters obliged, indulging Barney and her camera at mealtimes, during down moments, and mid-conversation. Her sister, Jill, became a favored subject for her photogenic nature and chameleon presence, but Barney also photographed other family members: her brother, Philip; Jill's daughter Polly; her own sons, Tim and Phil; as well as her friend Sheila and her daughter Moya. Often, the backdrops for these subjects are their own highly decorated, if overstuffed, interiors. Floral chintz fabrics and wallpaper, heirloom paintings, and wood-paneled libraries vie for attention behind equally well-appointed figures. *Jill and Polly in the Bathroom* (1987; p. 22), for example, shows two women paused mid-gesture as they navigate the coordinated confines of this particular room. Yet Barney's gift lies in confounding such easy descriptions. Coordinated bathrobes and décor heighten the intensity of the scene, but it is unclear whether Barney made this match or simply noticed it. The room's suffocating space and smothering pink tones

are alleviated only by Jill's act of drawing back the curtain to reveal something beyond the room and outside its color palette, a gesture that appears so natural it seems impossible to know if Barney choreographed it.[2] These two details alone indicate an approach that easily, even seamlessly, merges qualities that photographic history has often thought distinct: candid immediacy, documentary realism, and tableaulike direction.

Barney's photographs expose the emotional and psychological currents that course just beneath the surfaces of perfect trappings and banal gestures. In *Jill and Polly in the Bathroom*, such tension is evident in Jill's strained expression, Polly's turn away from her mother, and the distance between them that persists even in the cramped quarters of such a small room. "When people say that there is a distance, a stiffness in my photographs, that the people look like they do not connect, my answer is, that this is the best we can do. This inability to show physical affection is in our heritage."[3] While the myth that material comfort ensures personal contentment is an alluring one, Barney's photographs undermine such illusions, even in later images in which the focus has shifted away from the context to the personality and face of the sitter (see pp. 33–37). In these more recent photographs of family and friends—many of which eliminate any directorial impulse and allow for more self-presentation to the camera—Barney continues to make pictures distinct from family snapshots or formal group portraits in their refusal to serve as predictable commemorations of happy times, important gatherings, and ritualized affection.

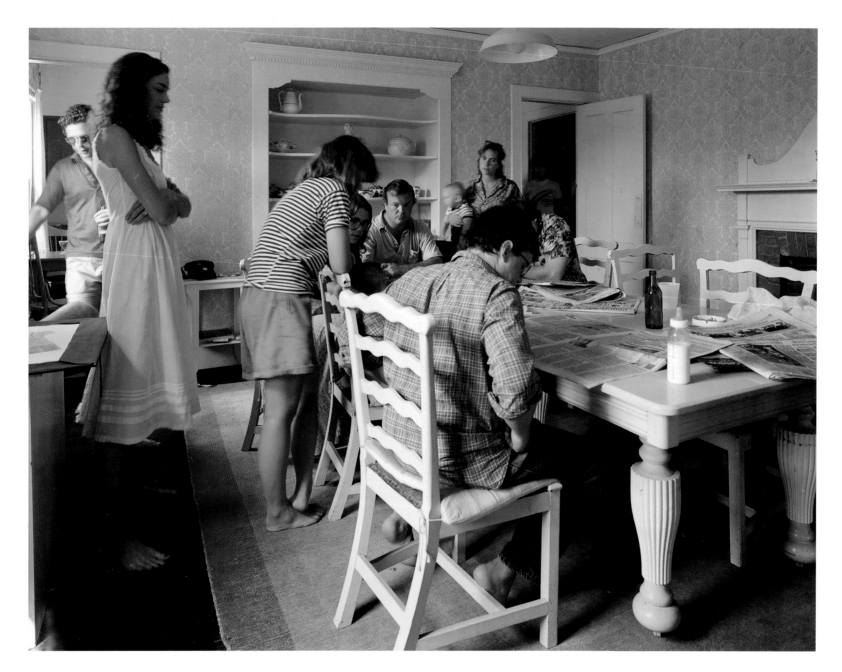

Sunday New York Times, 1982

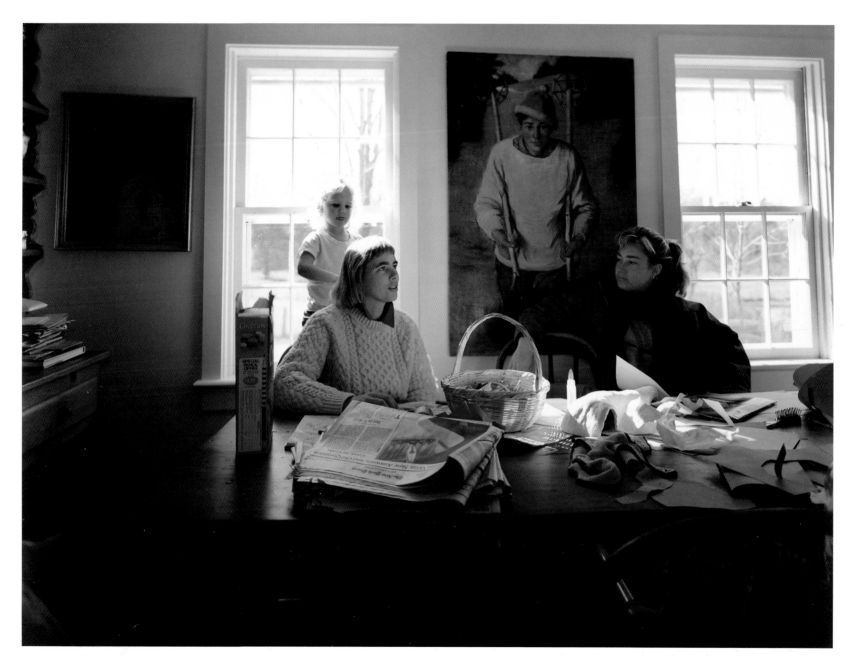

The Skier, 1986

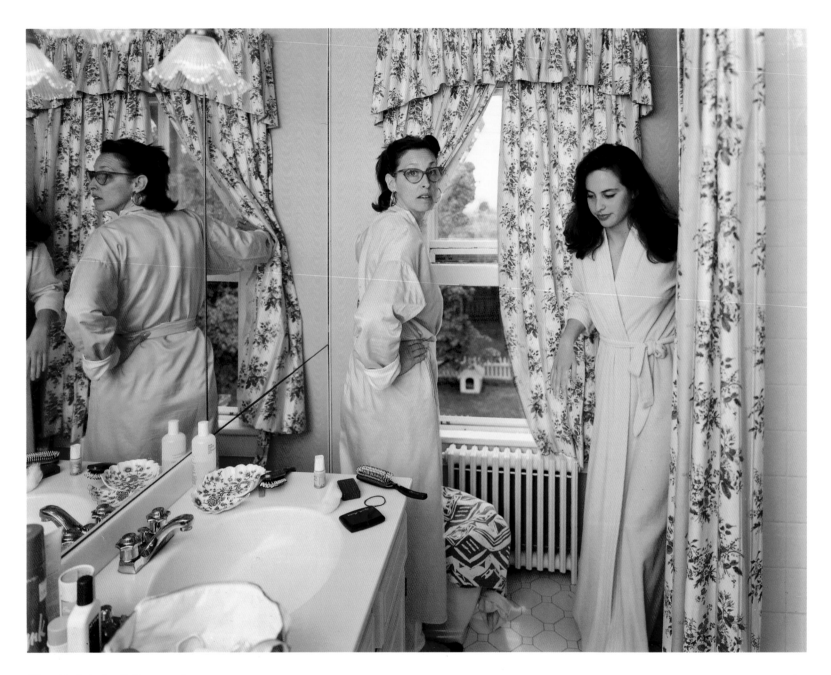

Jill and Polly in the Bathroom, 1987

Jill and I, 1990

Tim, Phil, and I, 1989 cat. 10

Phil and I, 1989

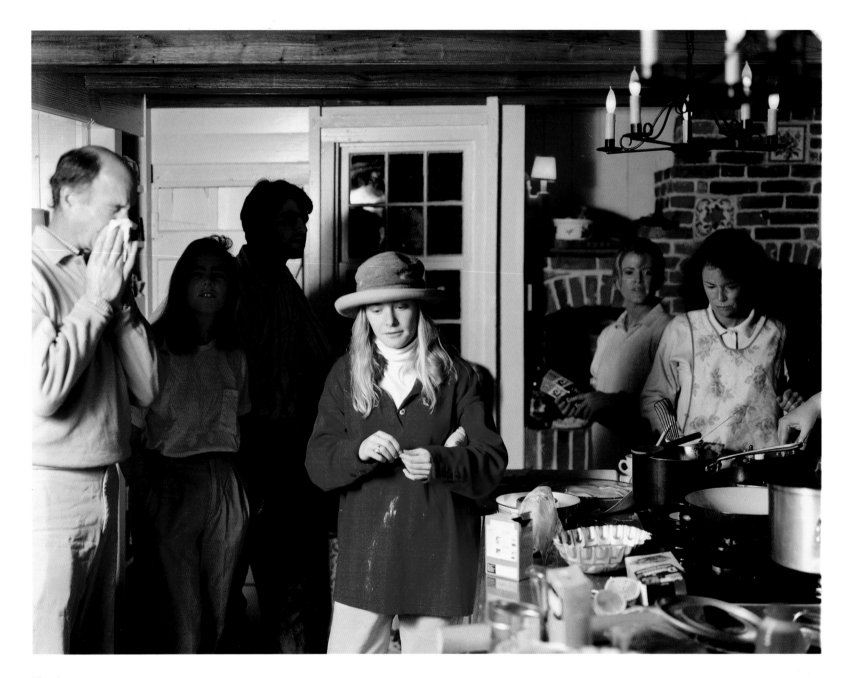

Thanksgiving, 1992

Lil and Jill, 1988

Jill and the TV, 1989

The Trustee and the Curator, 1992

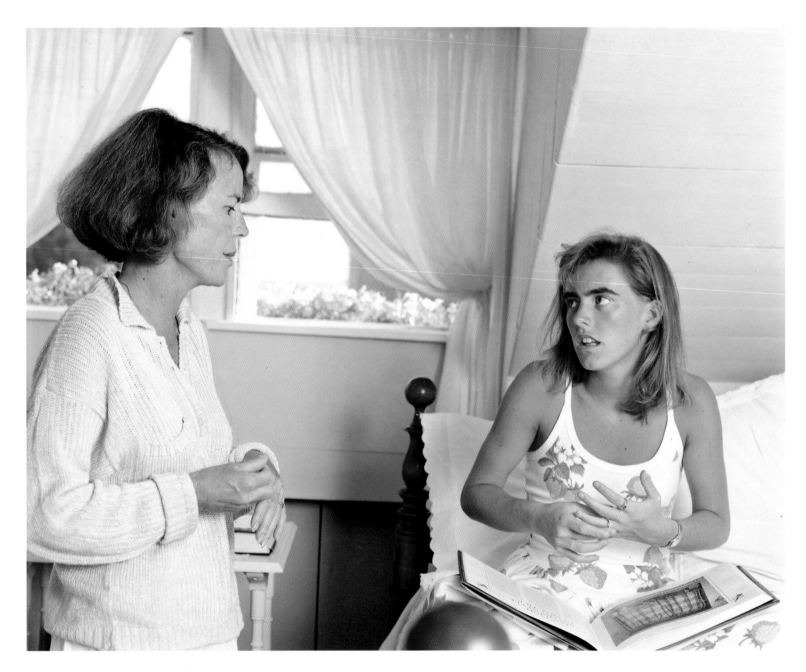

Sheila and Moya, 1987

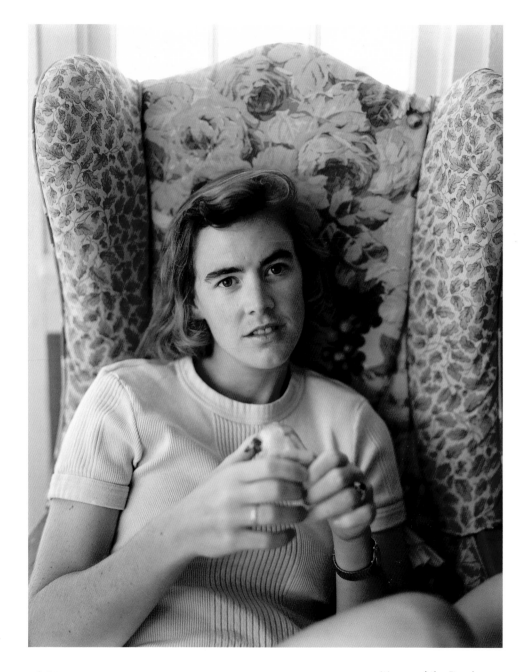

Moya and the Peach, 1997

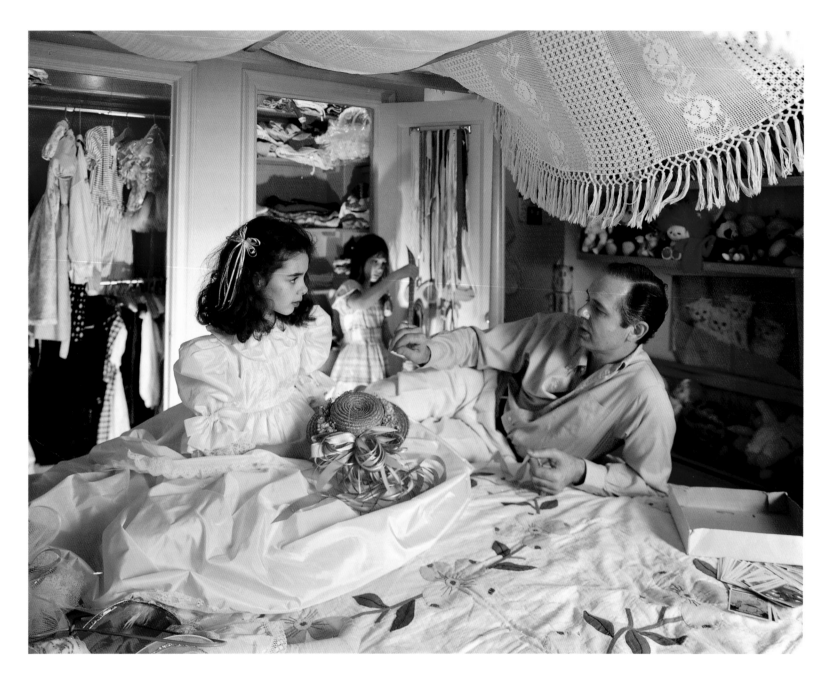

Marina's Room, 1987

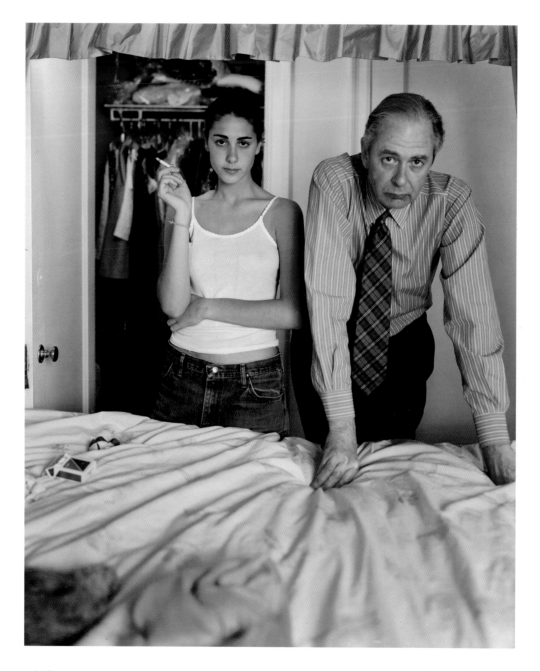

Marina and Peter, 1997

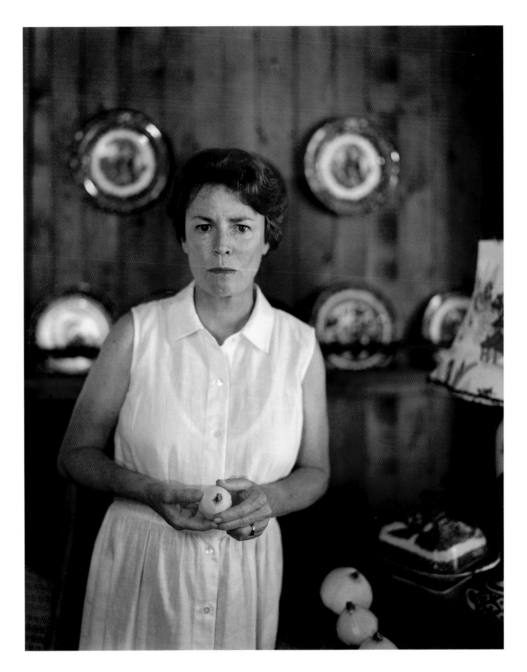

Sheila and the Squash, 1996

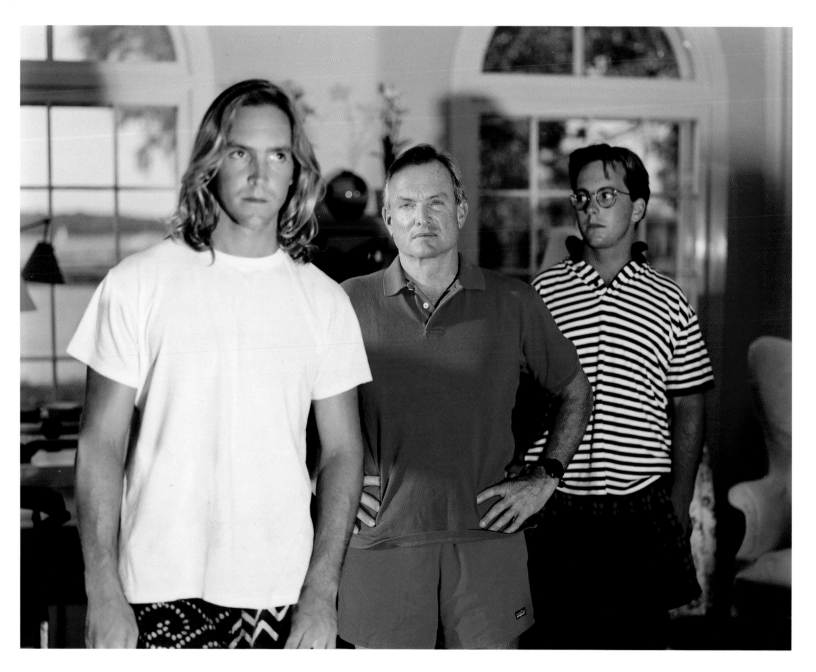

Tim, Philip, and Phil, 1993

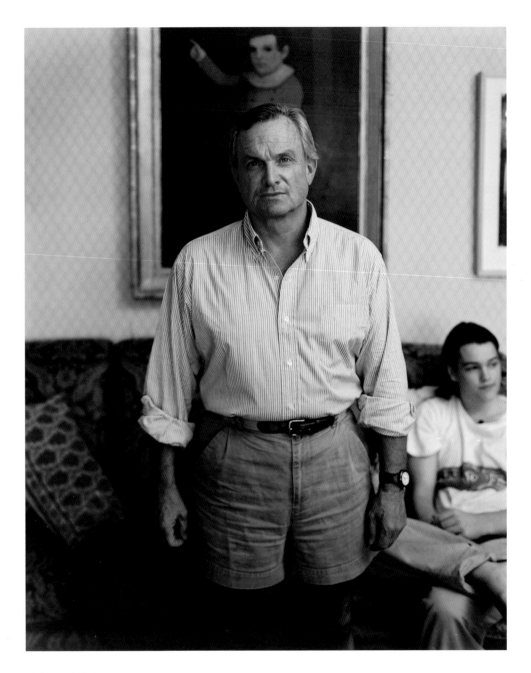

Philip and Philip, 1996

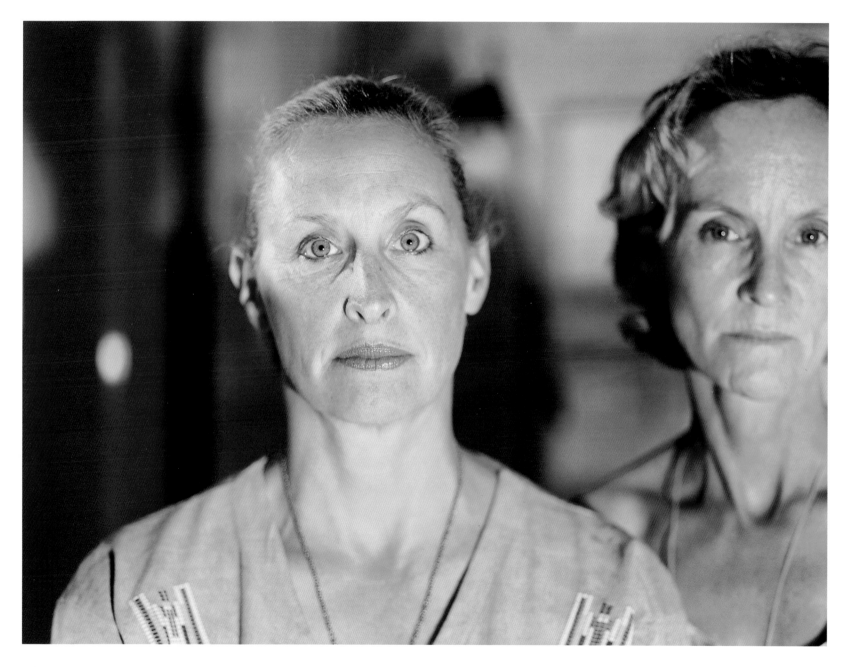

Jill and I, 1993

philip-lorca dicorcia

For his 2003 project *A Storybook Life*, Philip-Lorca diCorcia selected seventy-six photographs spanning three decades of his career, presenting them in a specific order. Conceived as neither a single body of work nor a mere sampling of past photographs, *A Storybook Life* instead constructs its meaning and narrative in part through the juxtaposition of the images, which encourage a kind of free association by viewers.[1] Unlike diCorcia's other projects, for which he hired models or photographed strangers on the street, almost all of the subjects peopling these pictures are drawn from his own life. Despite the real connections such intimate subjects might suggest, the title of *A Storybook Life* mimics fiction, or even the fantasy of a fairytale.[2]

DiCorcia began exploring his family as a photographic subject during the 1977 Christmas holiday at home in Hartford, Connecticut. These carefully planned but completely banal scenes present his family as characters in seemingly narrative tableaus. Some of the images appear to be scenes extracted from more complete narratives, such as a depiction of diCorcia's brother towering over a mid-century studio apartment, covered in the white dust of ceiling repairs, with its blinds taken down, light sockets exposed, and couch upturned (see p. 41). Other photographs are more ambiguous, creating anticipation about what comes next. In an opening image from *A Storybook Life*, diCorcia's father rests on a bed—possibly asleep after watching television—a tweed hat and duffle bag at his feet, an incongruous stuffed animal by his side, and a partially empty glass of white wine on the bedside table (see p. 40).

The final image in the project shows his father, again prone, lying in his casket against the far wall of a typical funeral home room, with endless yards of curtains and nondescript décor bathed in a warm, pink light (see p. 57). This final photograph was taken just one year after the opening one; yet other settings, people, and years collide in the tale diCorcia has arranged between these two images. Whatever personal significance the photographs may hold for the artist, diCorcia makes no claims about what effect they will have on viewers. Instead, they serve as an exploration of the emotional effect of image after image. The narrative sequence, then, is as deliberate as it is opaque, offering only suggestions about its possible meaning.

Partly, diCorcia confounds viewers' expectations of photographs, or more specifically of images in a seemingly narrative sequence, by limiting access to information. In amassing *A Storybook Life*, diCorcia chose not to reveal his personal associations to the subjects, instead providing only the dates and locations of the photographs. After all, photography's persuasive relationship to realism and documentation is continually in tension with its equally potent capability for fantasy and artificiality.[3] *A Storybook Life* foregrounds individual perception and, more precisely, how that perception invests the photographs with fluid, variable meanings. And, as meaning shifts and morphs in relation to each viewer's own condition, the narrative is continually altered, in flux, upended. As diCorcia's storybook life interacts with our own, a new fable begins.

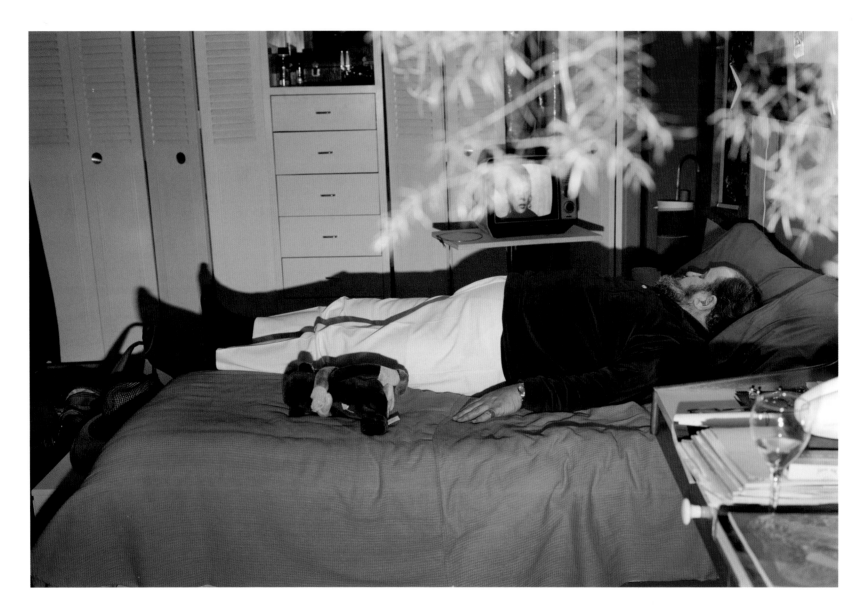

Hartford, 1979

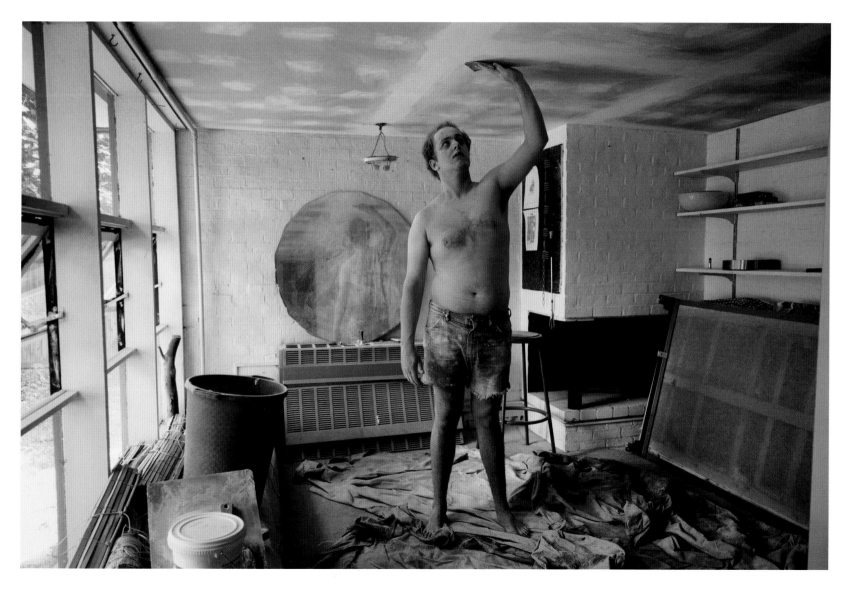

Hartford, 1980

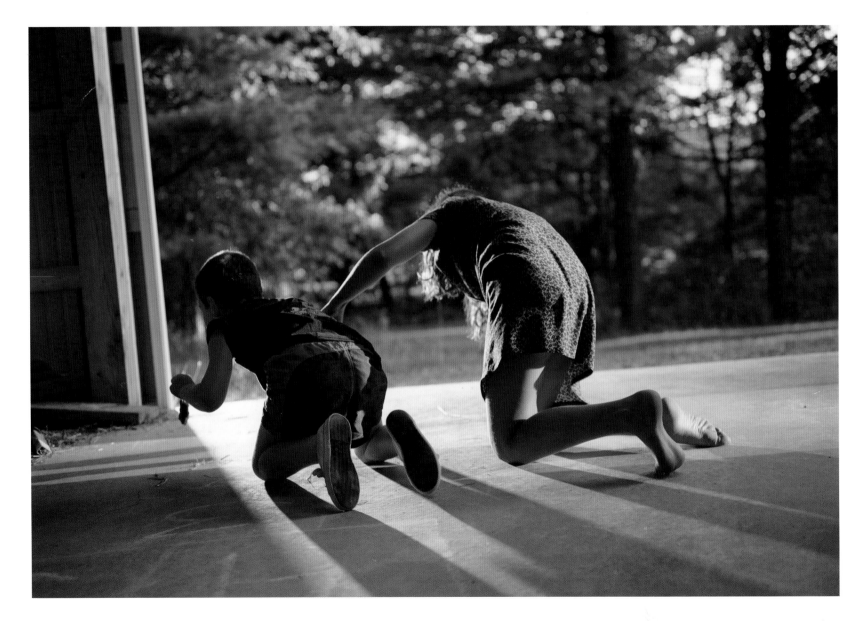

DeBruce, 1999

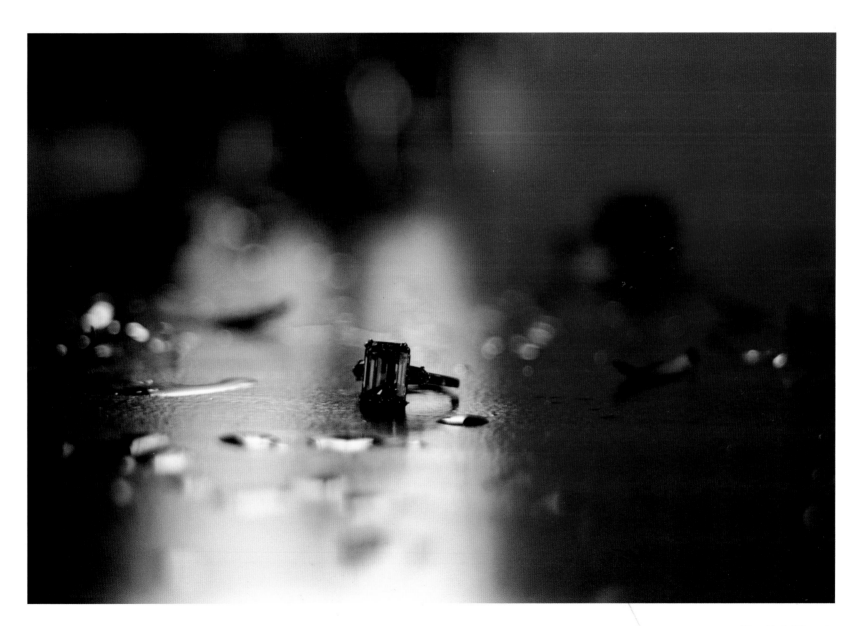

New York City, *1984*

Naples, *1994*

Hartford, 1978

Ouarzazte, 1991

Wellfleet, 1992 47

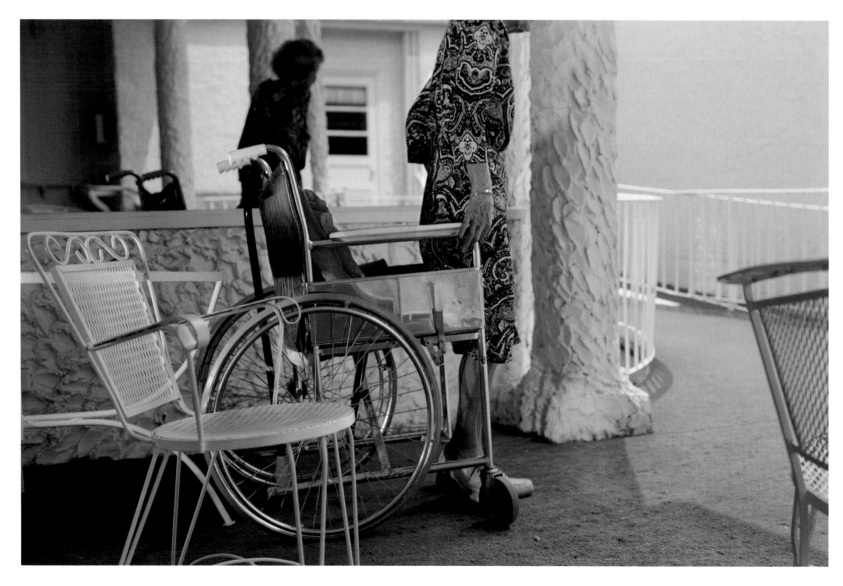

Hartford, 1980

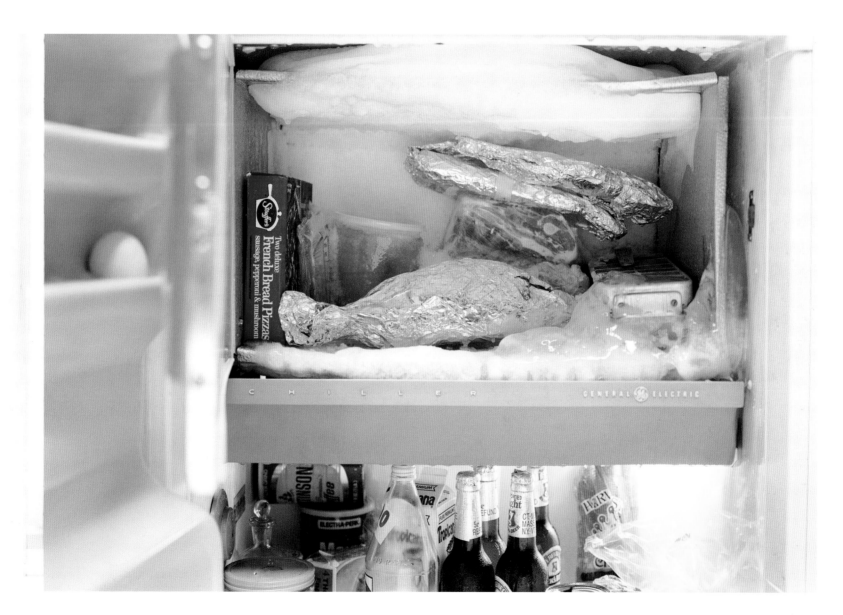

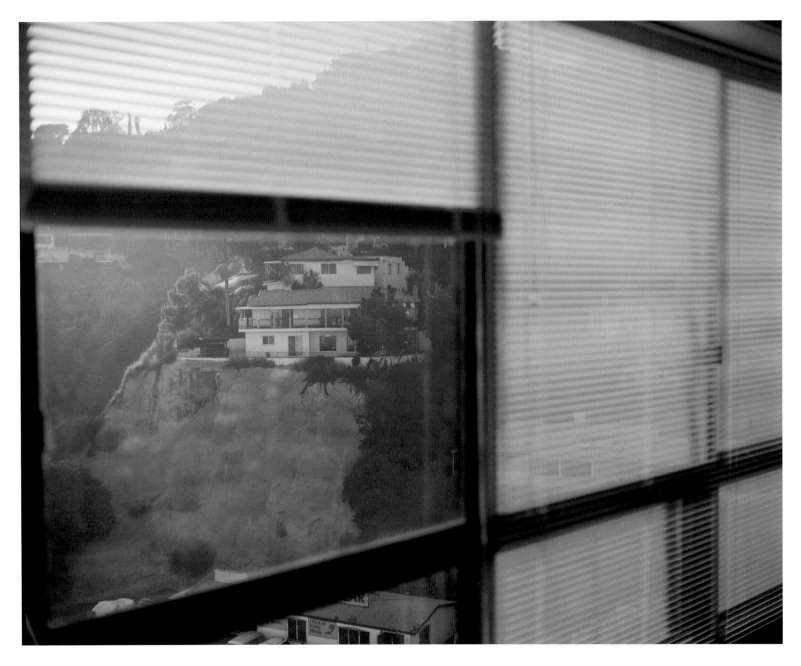

Los Angeles, 1997

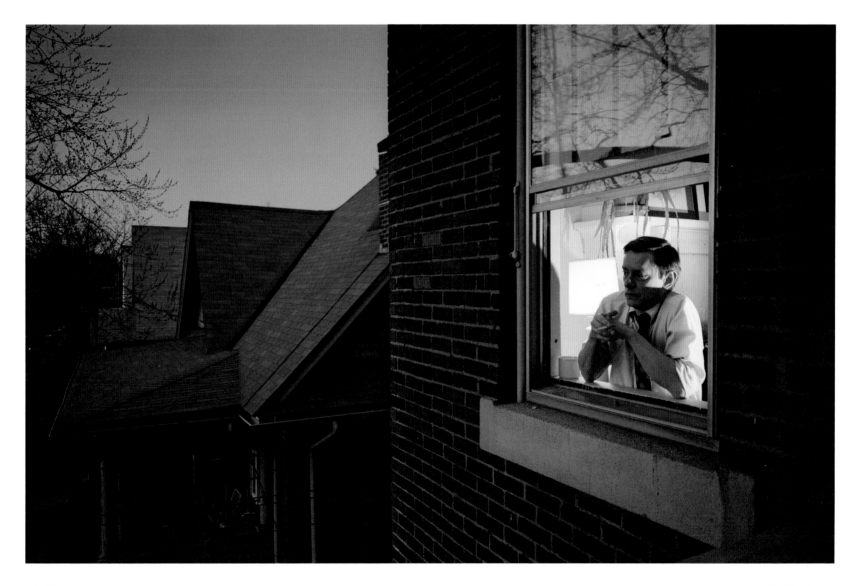

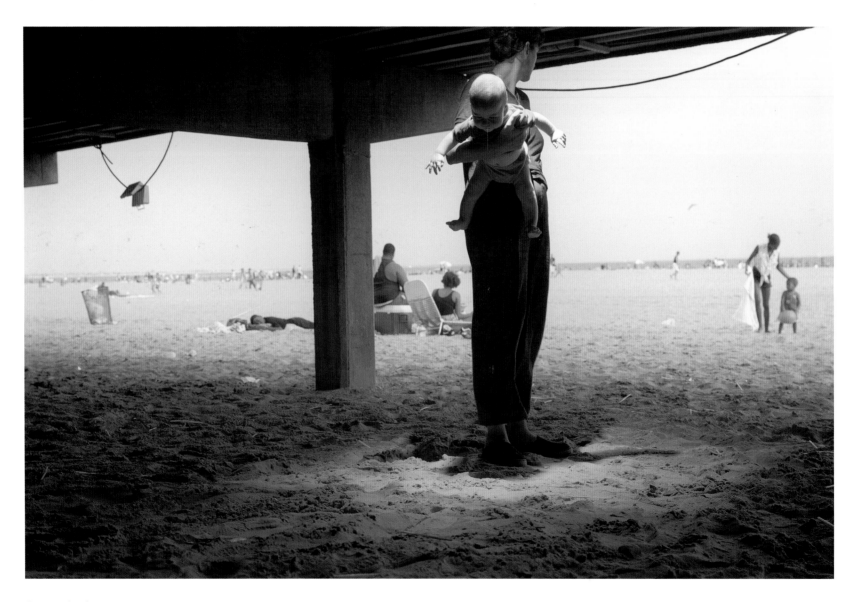

Coney Island, 1994

DeBruce, 1999

New York City, 1984

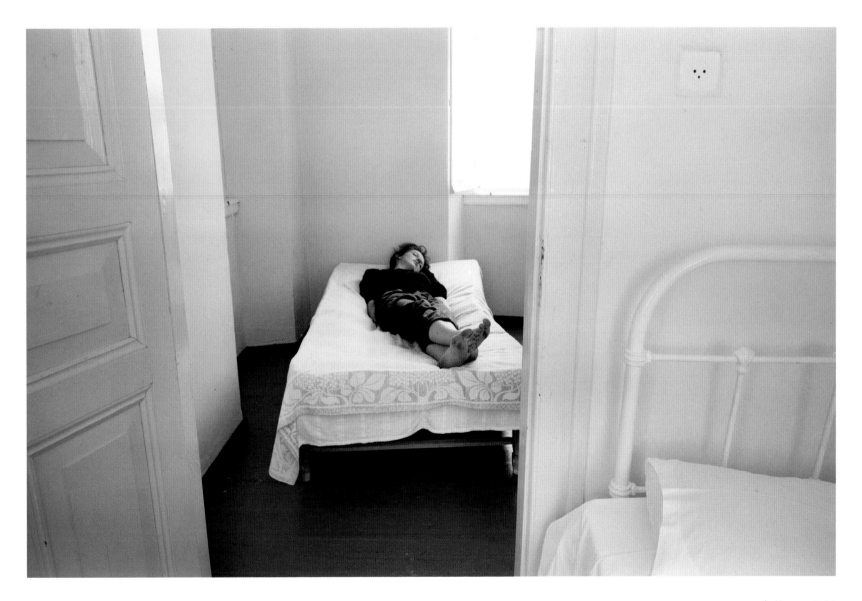

Antipaxos, 1980

Hartford, 1989

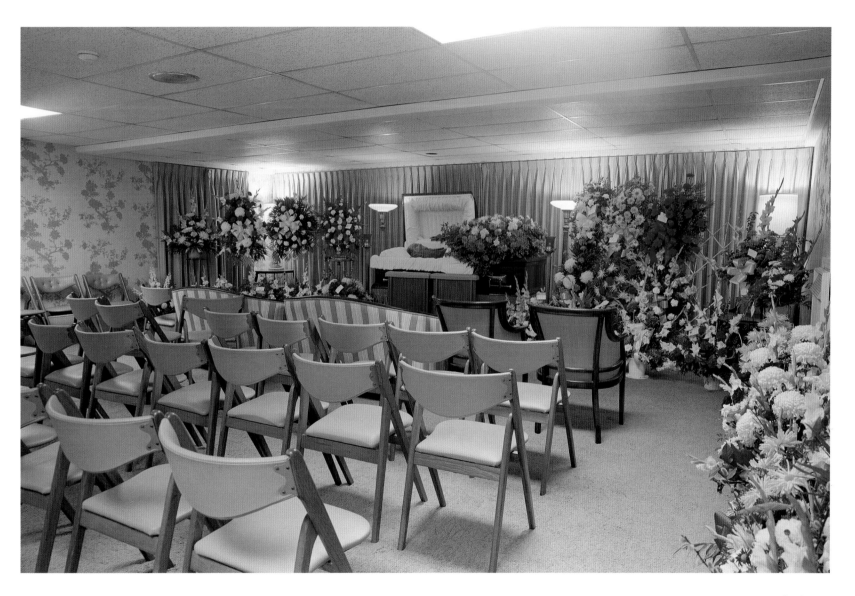

nan goldin

Arguably no artist, and certainly no photographer, of this era has created a more symbiotic relationship between life and art than Nan Goldin. For thirty-five years, it has been her obsession to record her world, and not once has she arranged or directed the subjects of her pictures. In a perfect complement of technique and subject, an unsteady finger on the shutter release matches the swoon of lovers or the euphoria of a party (see p. 62), just as warm, interior light steeps a figure in isolation, amplifying the shade of the drink in front of her (see p. 66).

Goldin has said of this fusion of approach and theme: "To photograph from your own life has these components of risk and uncontrollable possibilities and subtext that you can't impose upon photos; they come from experience."[1] Goldin, much like an early Kodak enthusiast, snaps away, fully embracing photography's potential for immediacy, emotion, and anecdote. Quite unlike either historical snapshots or today's family photos, her pictures present the very subjects considered outside the socially regulated realm. As viewers, we witness moments of utmost intimacy—lovemaking, violence, addiction, hospitalization—and the rollercoaster of human emotions that accompany them. We also see the artist herself over the years in numerous self-portraits, which are just as revealing and forthright as her photographs of others.

Goldin's most legendary work, The Ballad of Sexual Dependency (1979–2001), debuted as a slideshow in the clubs and cinemas of New York's artistic demimonde. Each time, Goldin set the show to different music and prepared new arrangements of the slides in order to more fully narrate the prevalent themes: couples, gender roles, love, dependency, and alienation. Pivotal to the piece was her own destructive and dependent relationship with a man named Brian. As the forty-minute show progresses, Brian and others appear, rushing forward on screen and receding again, in a cinematic mimicry of the nonlinear fashion of memories. Goldin's slideshow offers up a more exposed and potentially more honest version of the domestic slideshow ritual, a tradition that is just as culturally determined as that of the snapshot. Her photographs create a dialogue between socially accepted notions of identity, relationships, and community, and the experiences that fall outside of them.

Goldin's own youth, drug abuse, bisexuality, and her relationships with gays and transvestites placed her squarely in the midst of what would become known as the AIDS crisis. Her closest friend and longtime subject, the artist Cookie Mueller, died from the disease on November 10, 1989. That same day, Witnesses: Against Our Vanishing opened in New York. The exhibition, curated by Goldin, marked the first significant gathering of art about and by those with AIDS, and led to a national day of awareness. Reflecting on her photographs of Cookie, Goldin has said, "I used to think I couldn't lose anyone if I photographed them enough. . . . In fact, they show me how much I've lost."[2] In Gotscho kissing Gilles (1993; p. 70), Goldin portrays the tender, excruciating emotions of loss, just as she has captured the delight of a first love in her photographs of Simon and Jessica (see p. 75), or the enthrallment with a new love of her own (see p. 76). Indeed, her pictures are relatable glimpses into the complex nature of relationships, prompting us to consider what the photographic story of our lives might look like if we included such revealing pictures of our own.

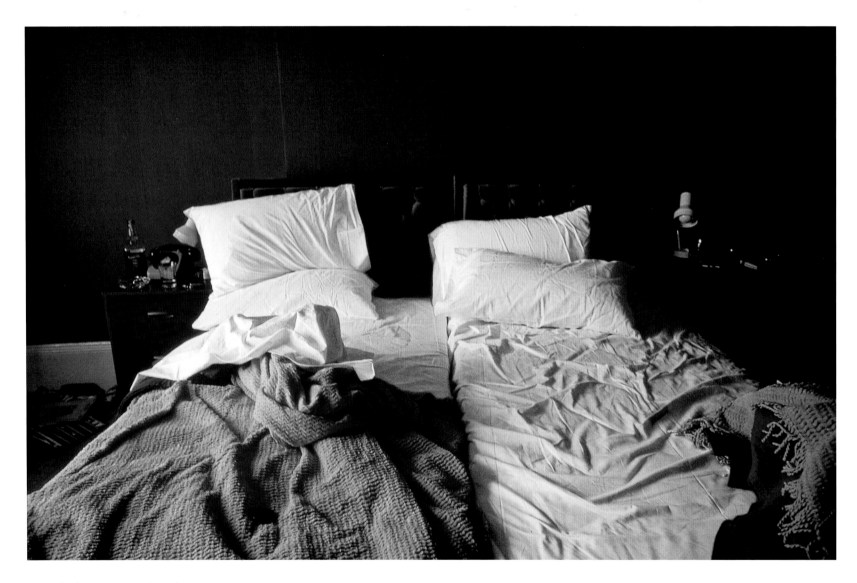

Empty beds, Lexington, Massachusetts, 1979

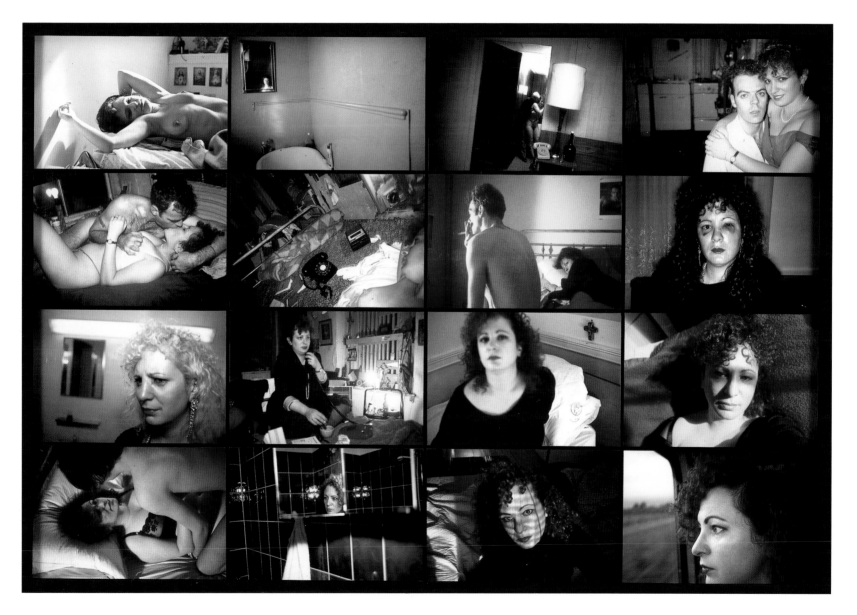

Self-portrait, 1978–94/95

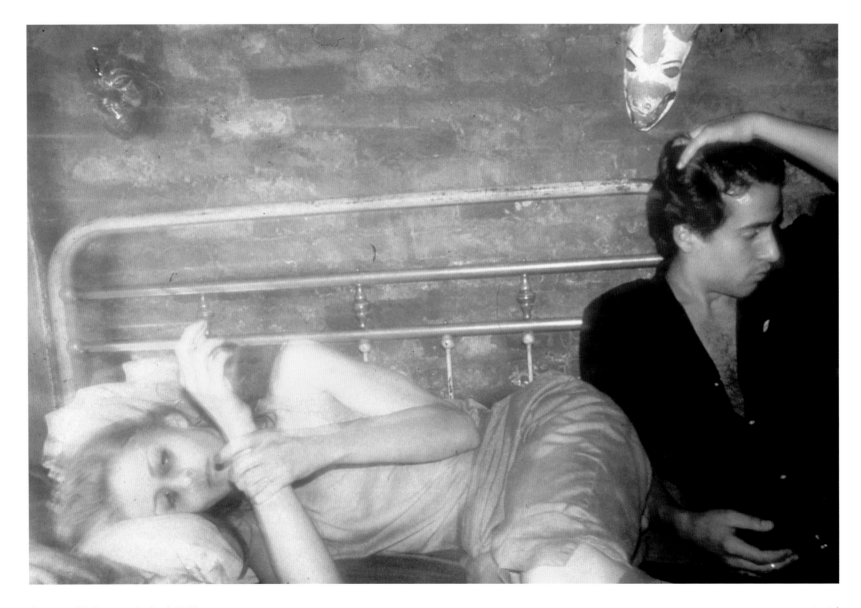

Greer and Robert on the bed, NYC, 1982

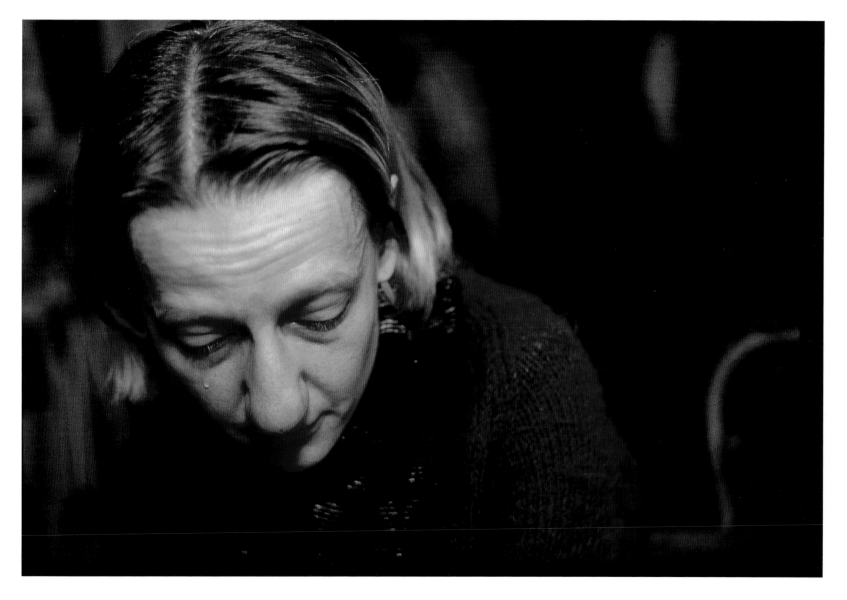

Suzanne crying, NYC, 1985

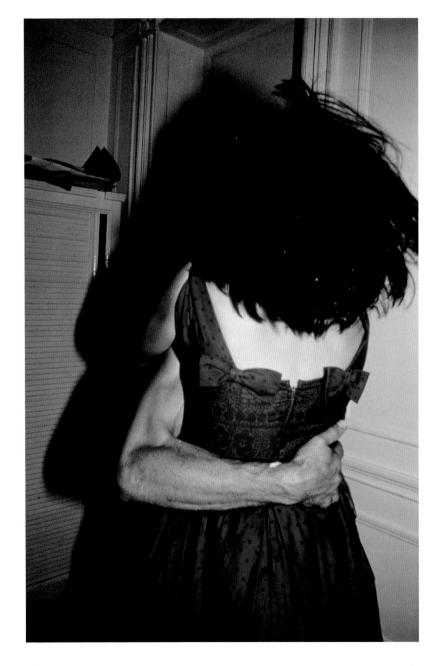

The Hug, 1980

The Parents' wedding photo, Swampscott, MA, 1985

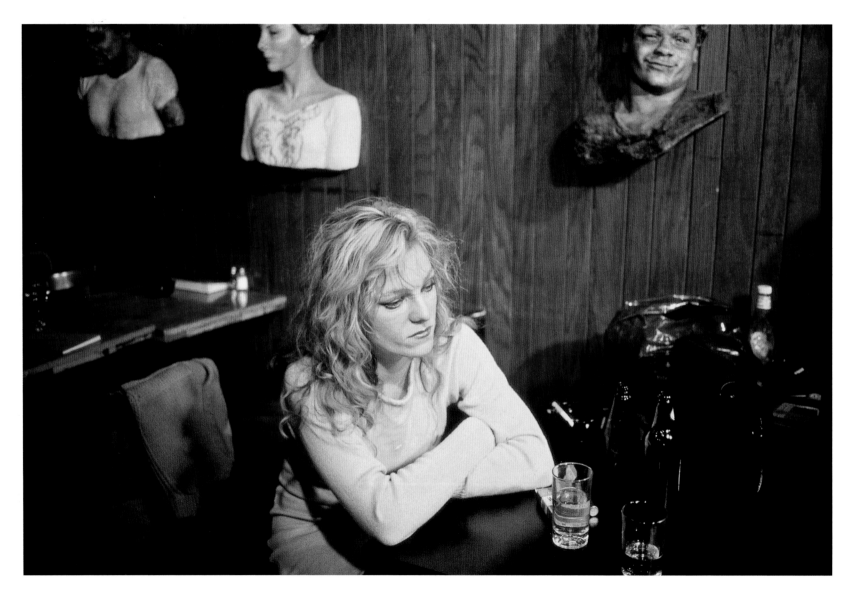

Cookie at Tin Pan Alley, NYC, 1983

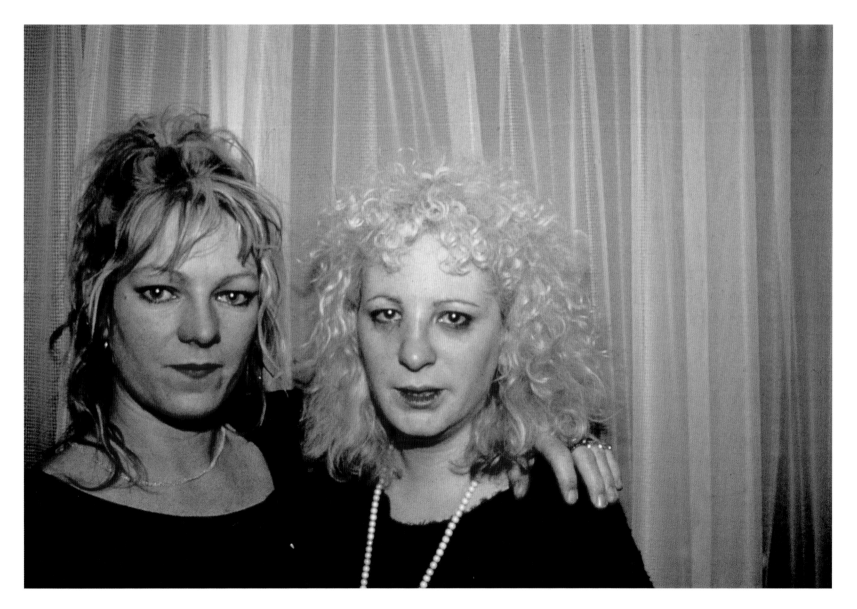

Cookie with me after I was punched, Baltimore, MD, 1986

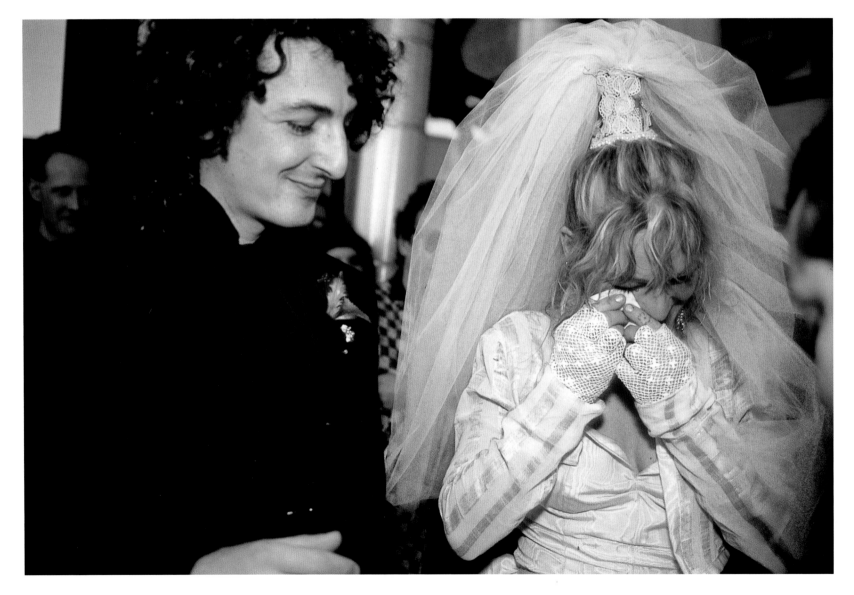

Cookie and Vittorio's wedding, NYC, 1986

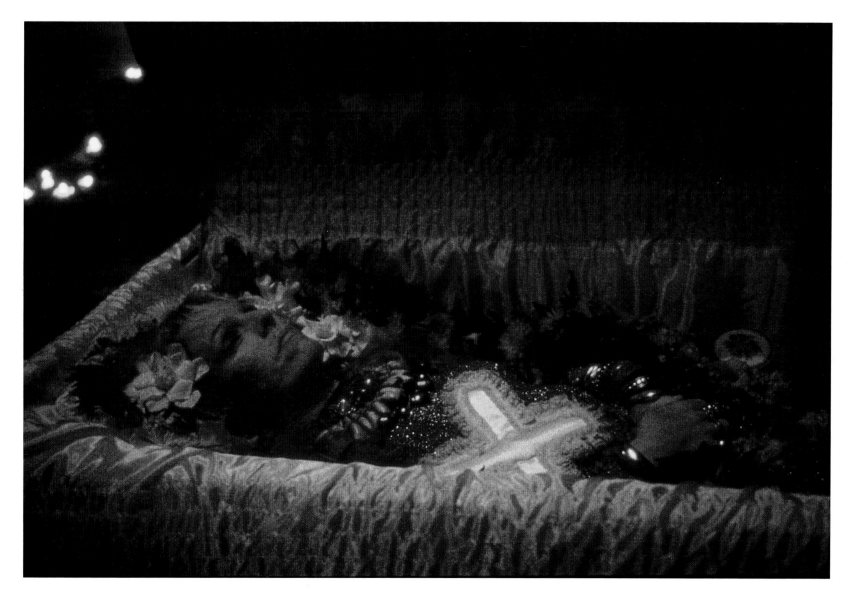

Cookie in her casket, NYC, *November 15, 1989*

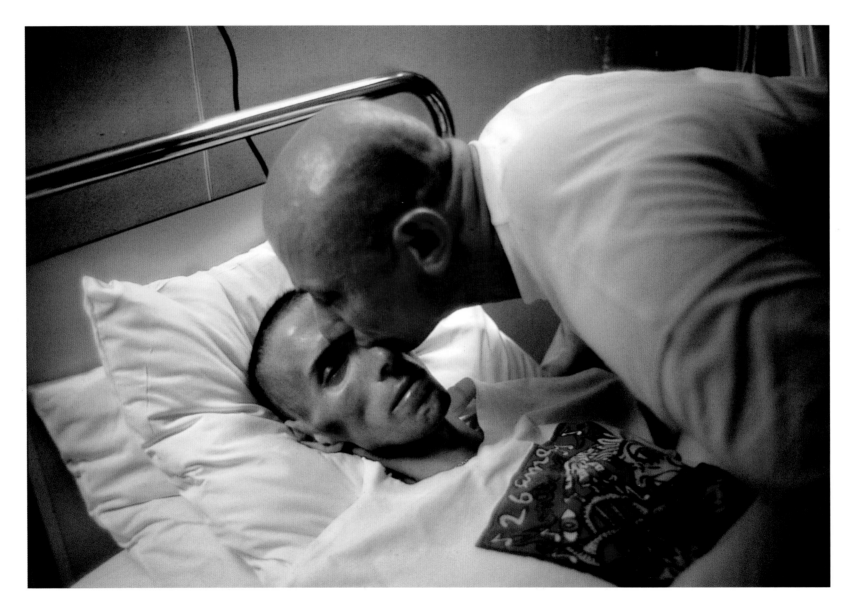

Gotscho kissing Gilles, Paris, 1993

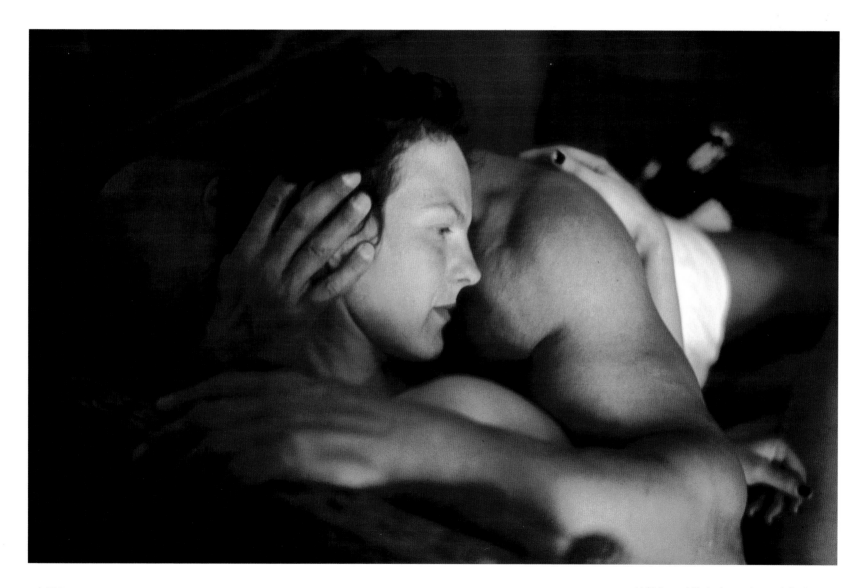

Valérie and Gotscho embraced, Paris, 1999

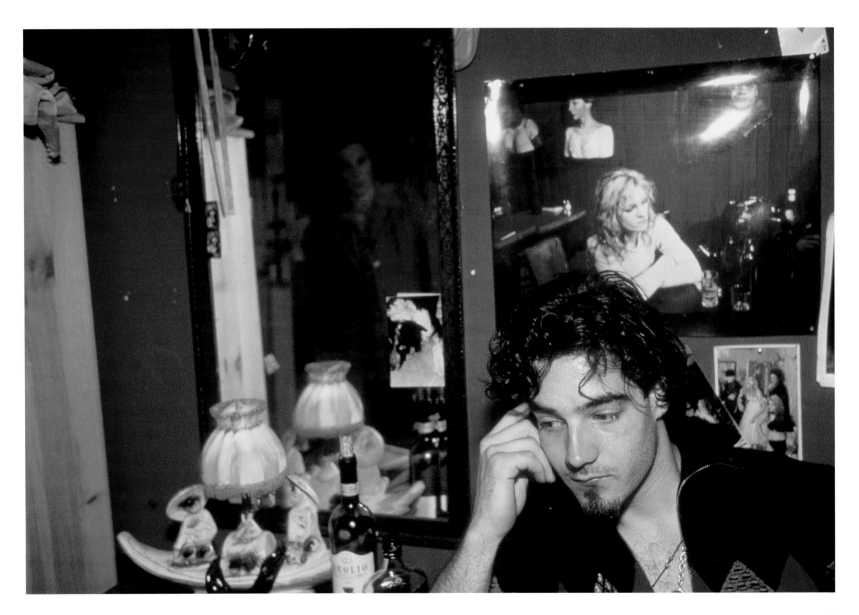

Max at Sharon's apartment under photograph of his mother Cookie, NYC, 1996

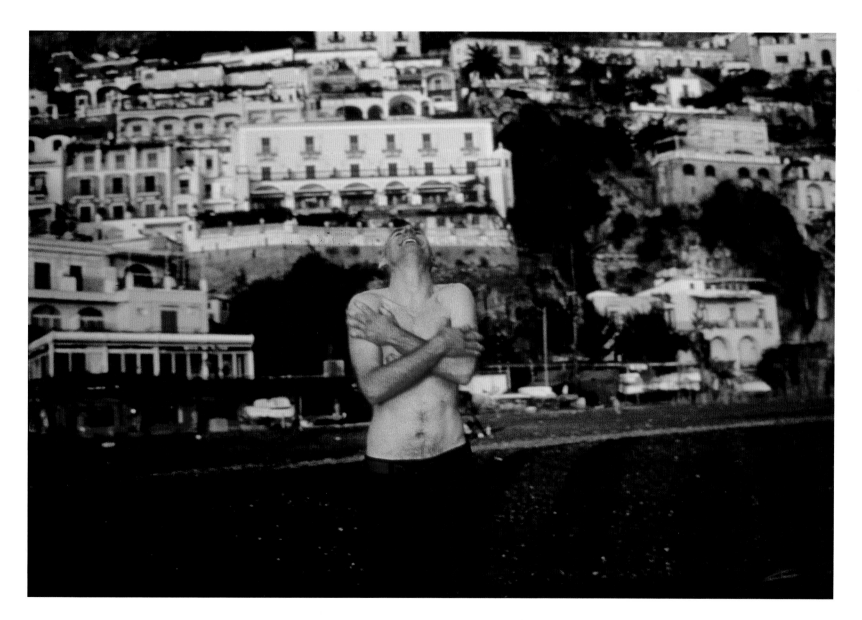

Pawel laughing on the beach, Positano, 1996

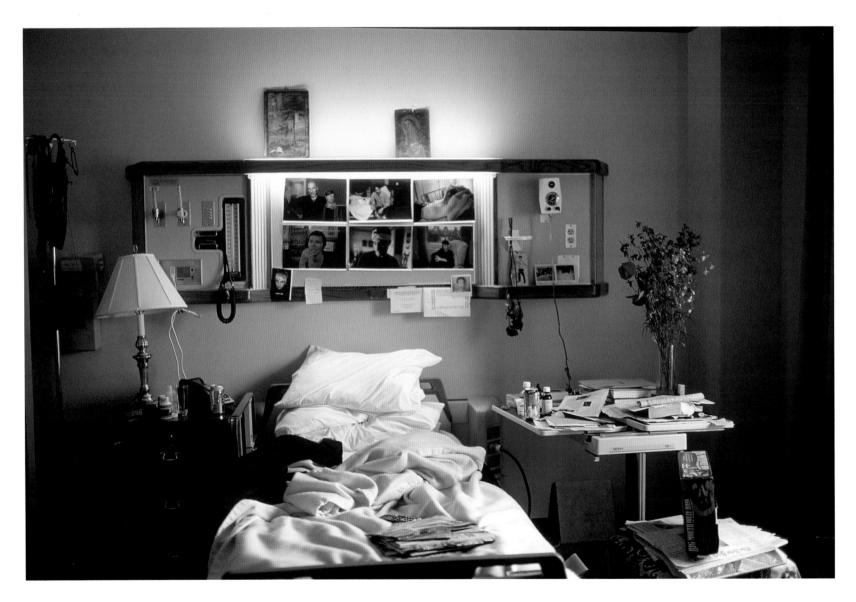

Decorated bed, Suite 22, Roosevelt Hospital, NYC, 2000

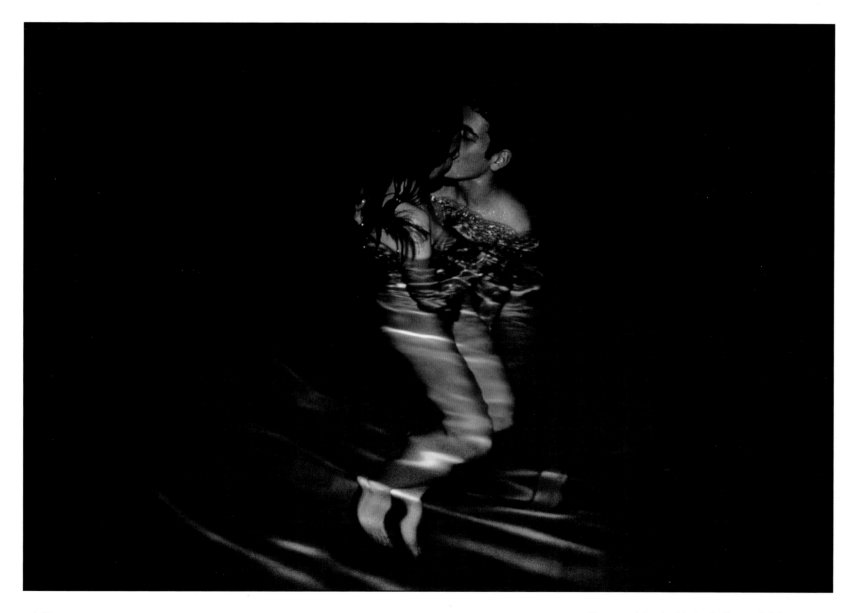

Simon and Jessica kissing in the pool, Avignon, 2001

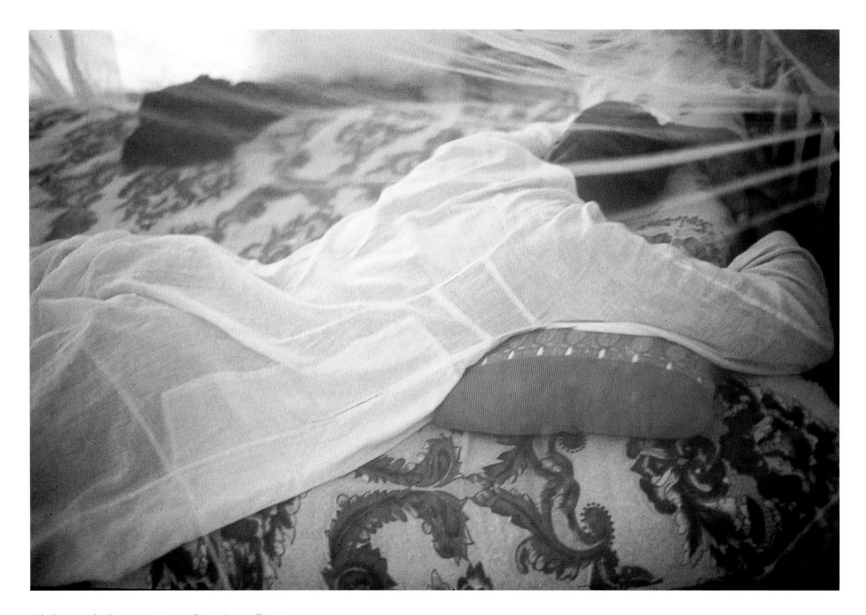

Jabalowe under his mosquito net, Barat, Luxor, Egypt, 2003

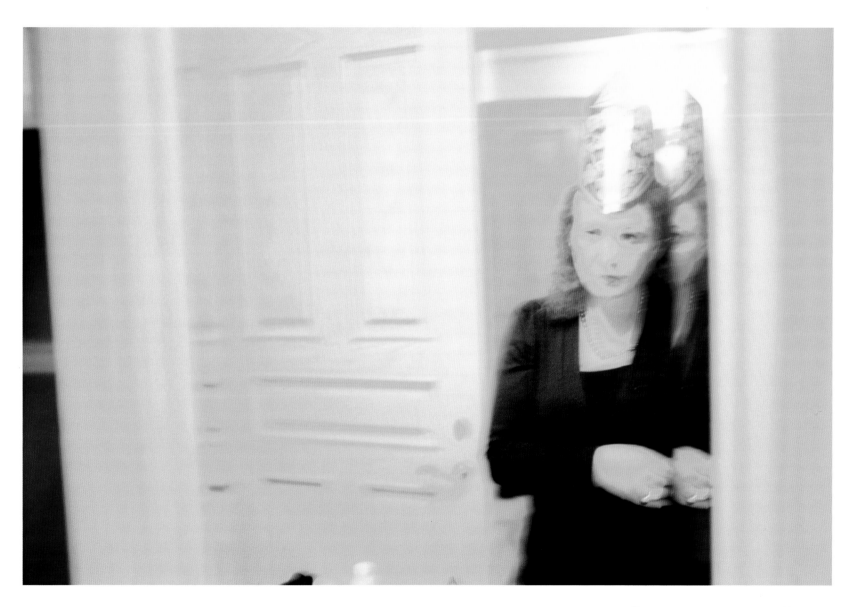

Self-portrait at New Year's Eve, Malibu, 2006

sally mann

If Sally Mann has a constant muse, it is her surround, with its two sometimes-overlapping components: her family and the land. Mann has consistently turned her camera on these two most immediate subjects, and the resulting images are at once ordinary and profoundly personal scenes.

Mann began photographing her three children—Emmett, Jessie, and Virginia—every summer from the time they were infants in the mid-1980s. This evocative, intimate body of work, aptly titled *Immediate Family* (1985–92), captures her children's playful, beautiful, and messy lives in the foothills of the Blue Ridge Mountains in rural Virginia. In certain cases, the photographs have a recognizable quality: "Some are fictions, some are fantastic, but most are of ordinary things every parent has seen—a wet bed, a bloody nose, candy cigarettes."[1] Mann's representation of these ordinary moments, however, combined with the fact that she viewed the project as an intense collaboration with her children, makes her images far from typical family pictures: "We are spinning a story of what it is to grow up. It is a complicated story and sometimes we try to take on the grand themes: anger, love, death, sensuality, and beauty. But we tell it all without fear and without shame."[2]

This clarity of purpose became increasingly important as the Culture Wars controversy surrounded Mann's photographs, particularly those in which her children appear nude.[3] Concerns included the sale of such provocative works; gendered assumptions about a mother's role as protector; the consent of the children; and the possibility that these pictures might prompt inappropriate actions.[4] The very scope of issues that Mann's photographs raised indicated their success in confounding viewers' expectations, arousing unmentionable fears, and challenging assumptions about childhood innocence.

If these debates formed the cultural backdrop to the *Immediate Family* photographs, artistically they did not overshadow the actual setting of the images, many of which were made on the family farm or in Mann's own childhood home. Rooted in her native landscape, Mann's field of vision slowly expanded so that by the mid-1990s her children had become but one component of a broader scene. She photographed her family's farm directly, focusing on the river rather than employing it as a setting for summer idylls (see p. 89). Made with a large-format camera and embracing the uncertain nature of nineteenth-century photographic processes, the resulting images are dark, romantic, saturated views of the South, which bring to mind a paradise lost, a forgotten memory, or the setting of a William Faulkner novel.

In 2004 Mann returned to photographing her children, who are now grown. Her continued use of antiquated techniques and the lengthy exposures they require has purposely marked these extreme close-ups with chanced flaws, hazy auras (even exhalations), and intense gazes. While different for their absence of context, the recent portraits nevertheless retain those elements that are so strikingly familiar from the most haunting of the *Immediate Family* pictures: the fierce sense of presence and its ensuing testimony to time's passing that comes from Mann's studied appreciation of those things held most dear.

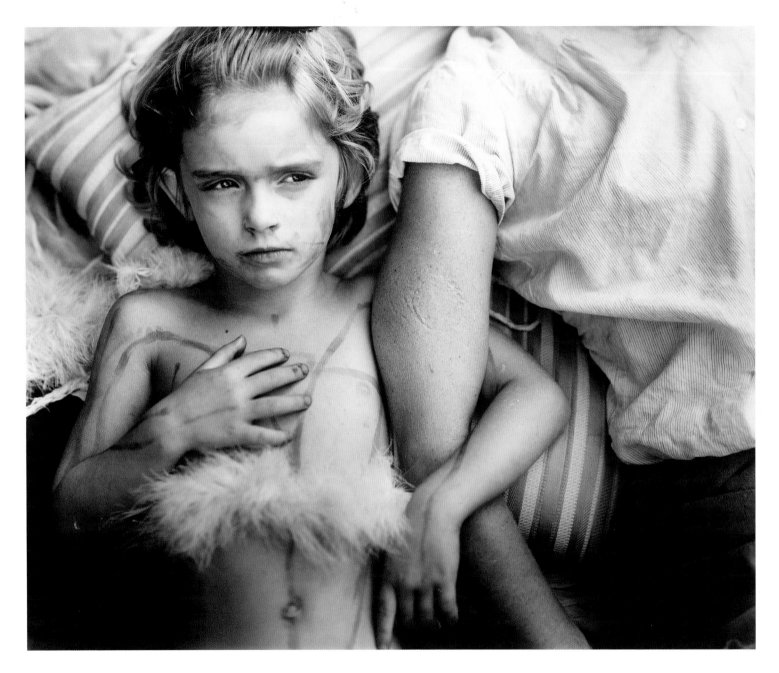

Jessie Bites, 1985

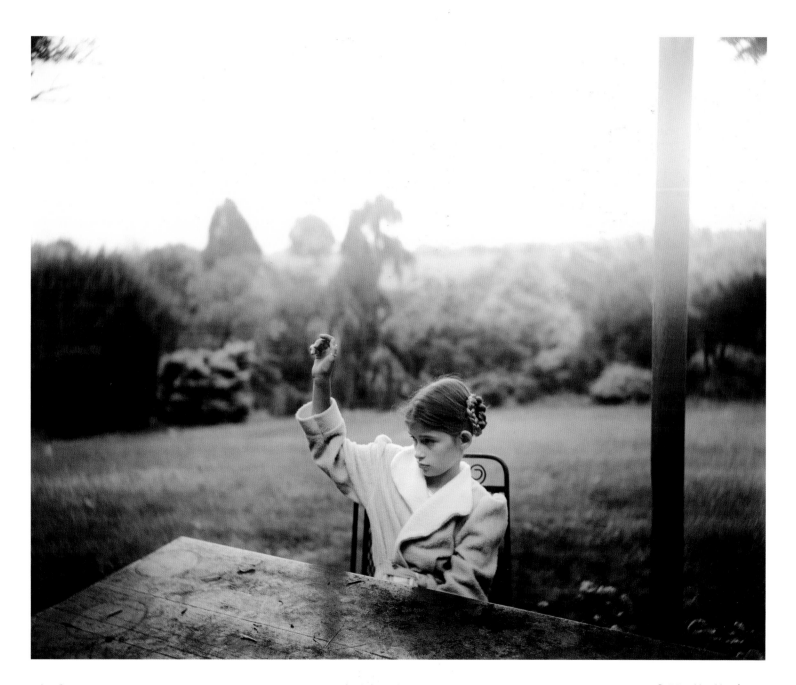

Raising Her Hand, 1992

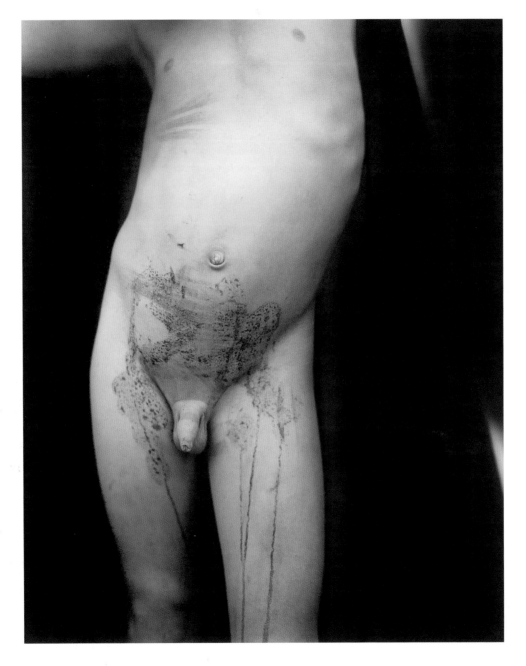

Popsicle Drips, 1985

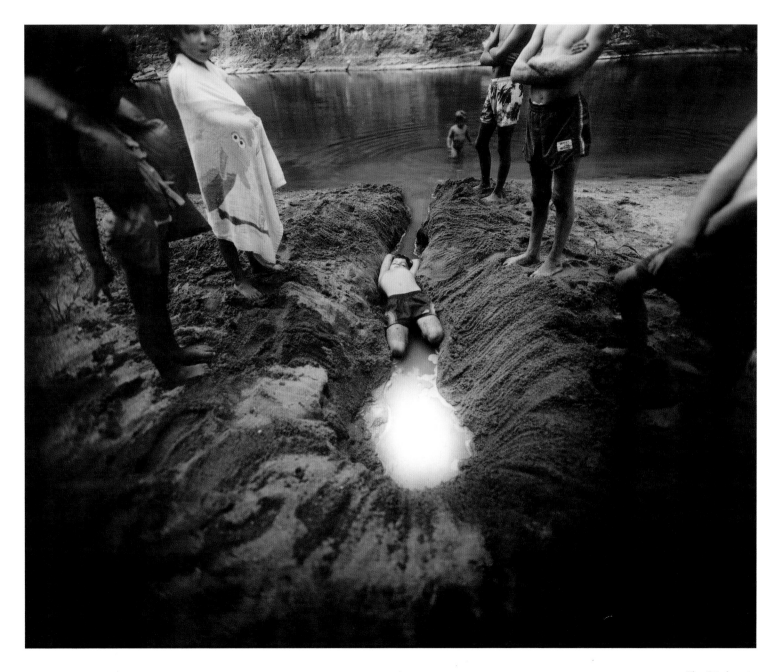

cat. 122

The Ditch, 1987

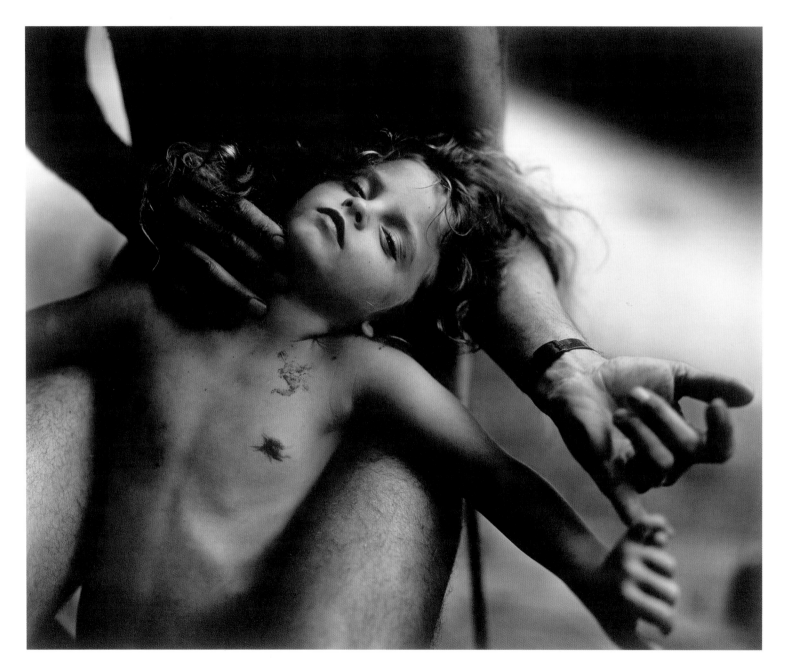

84 **Last Light,** 1990

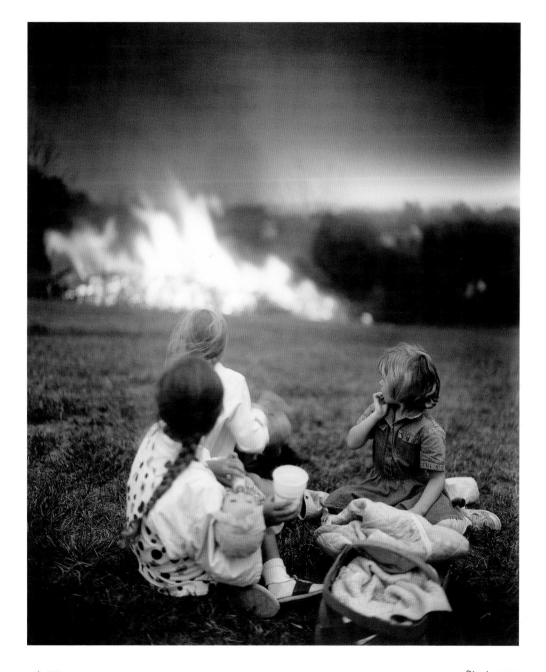

Picnic, 1992

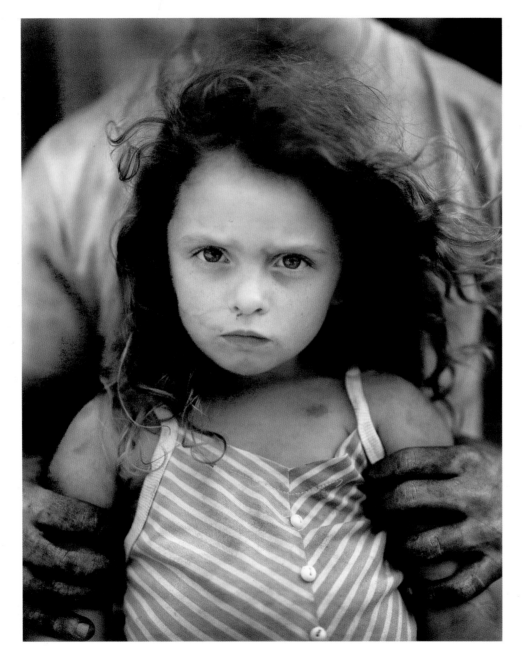

Holding Virginia, 1989

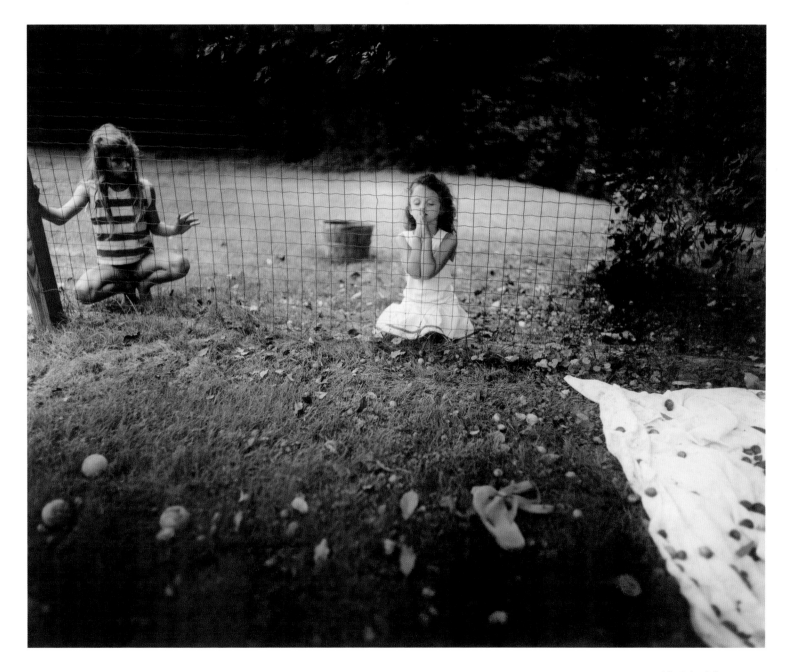

Virginia at Prayer, 1991

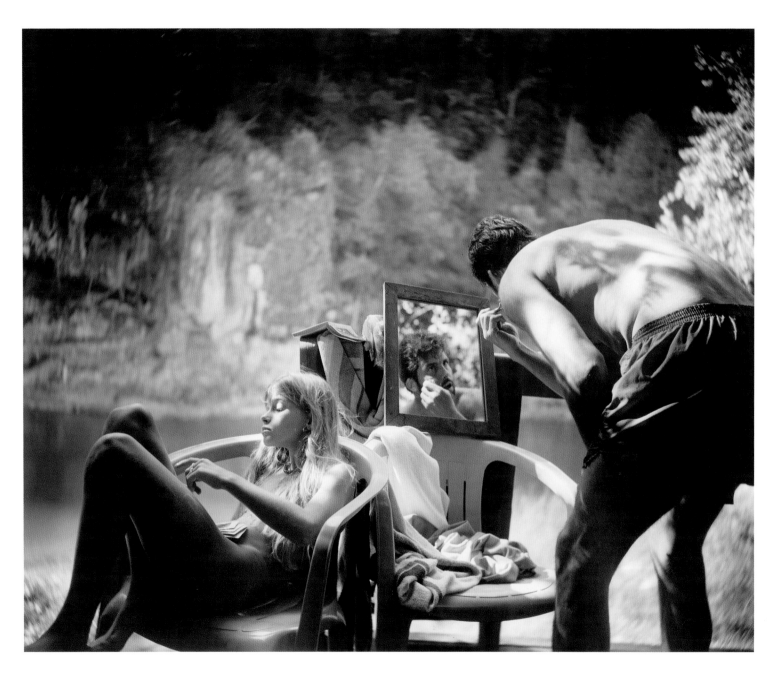

Larry Shaving, 1991

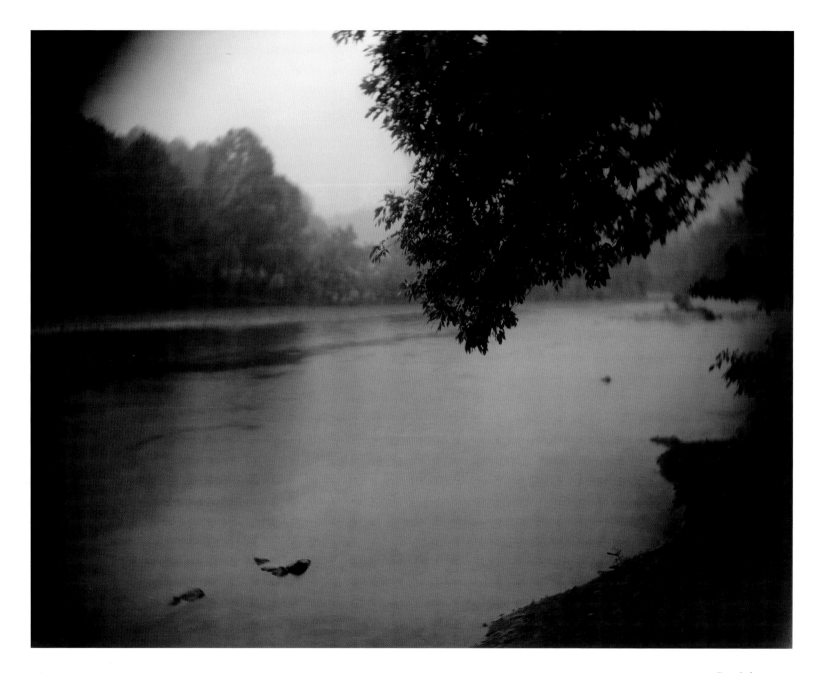

Ben Salem, 1995

Blue Hills, 1993

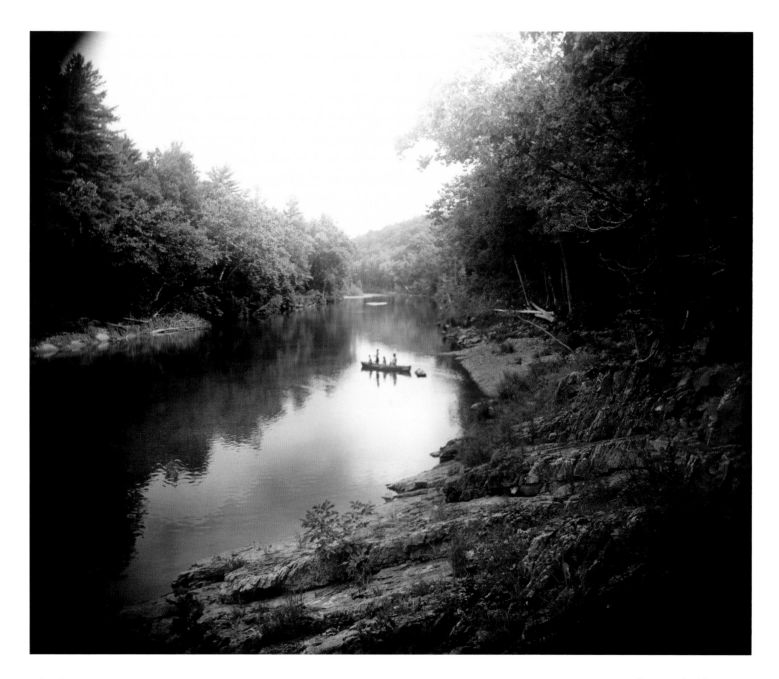

Crossing the Maury, 1992

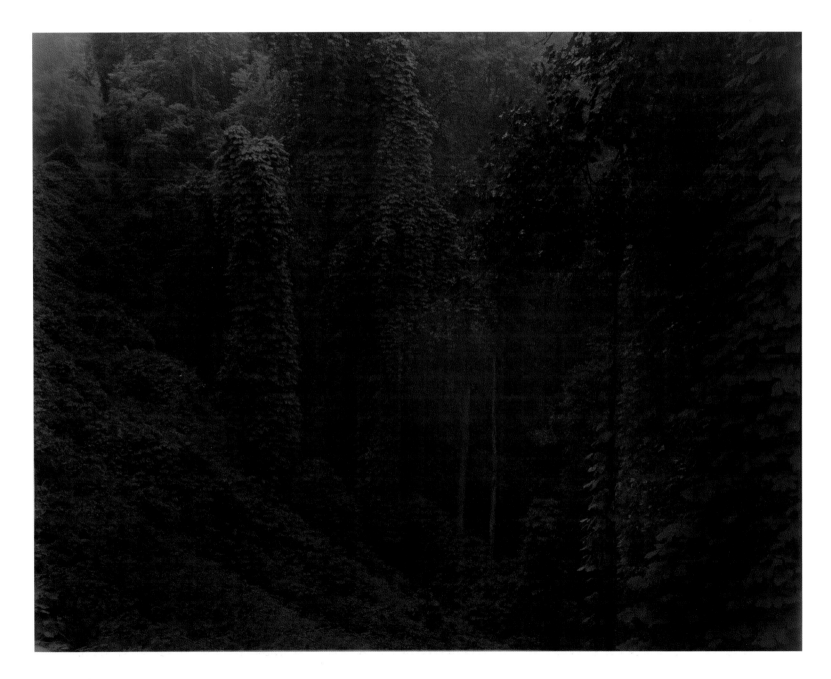

Virginia Kudzu, *1996*

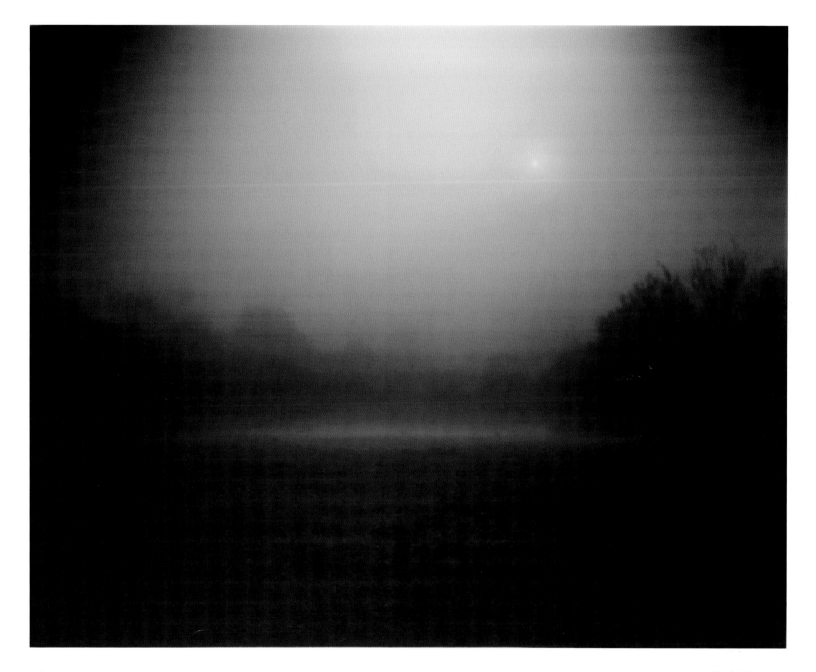

Dark Mist, 1996

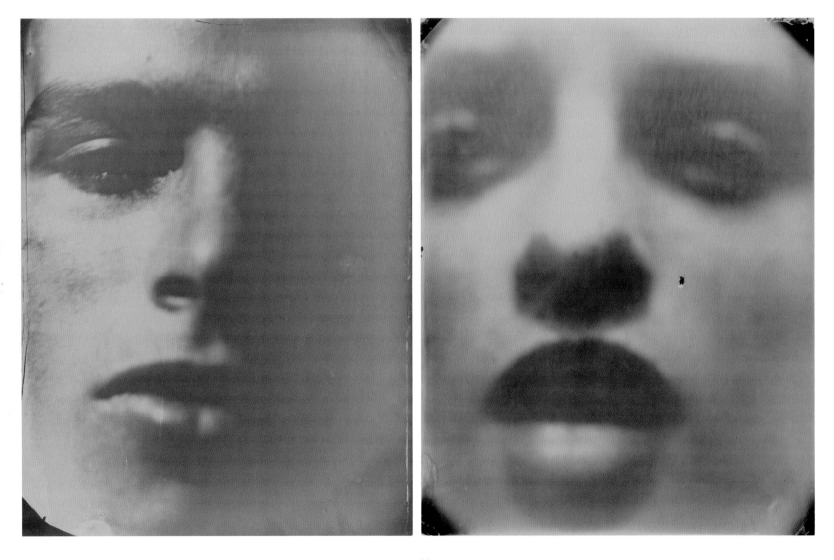

Emmett 45, 2004 cat. 148 Virginia 9, 2004 cat. 152

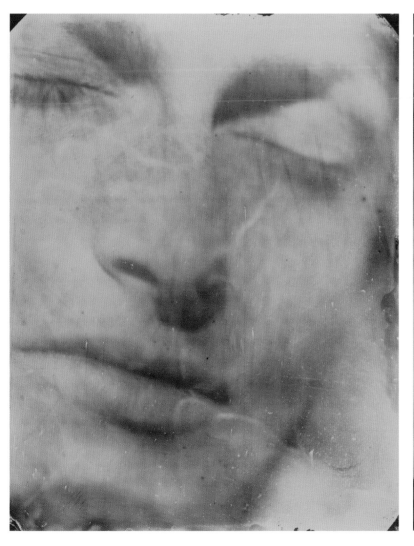

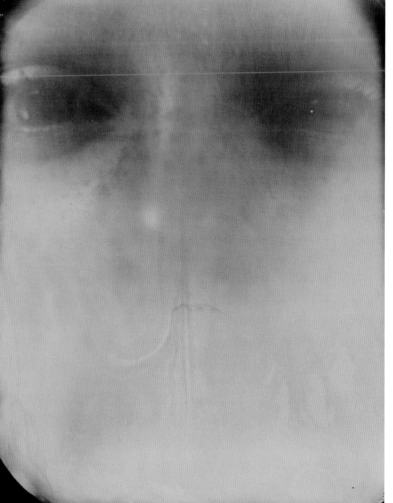

cat. 150 **Jessie 25,** 2004 cat. 154 **Virginia 37,** 2004

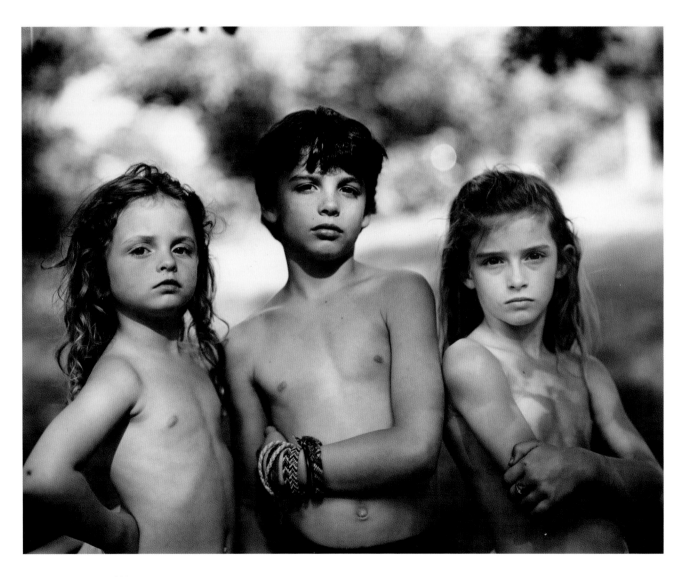

Emmett, Jessie, and Virginia, 1989

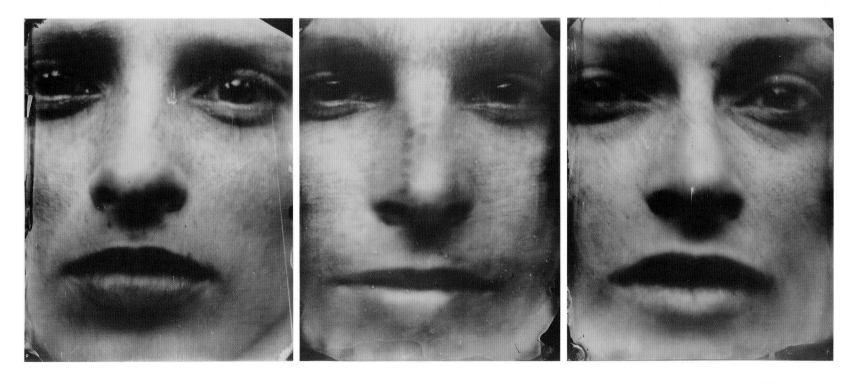

Triptych, 2004

larry sultan

In 1982, while visiting his parents in Los Angeles, Larry Sultan pulled out a box of old home movies that the family had not watched in years. Astounded by the films, Sultan later commented, "They were remarkable, more like a record of hopes and fantasies than of actual events. It was as if my parents had projected their dreams onto film emulsion."[1] Family albums, reels of home movies, and the tales they prompt all help to construct and define, individually and collectively, the term "family." What is pictured on the album page or living room wall—and what is left unpictured—attests to a common desire for a tale of domestic happiness.

In his project *Pictures from Home* (1982–91), Sultan used his own contemporary photographs as pendants to his parents' old films and snapshots, exploring a more complete, complex sense of family. The chronological distance separating these two components raises questions of history, memory, and time. The child photographing his parents reverses the social norm, complicating the sense of power, identity, and self-creation experienced on either side of the camera.

> What drives me to continue this work is difficult to name. It has more to do with love than with sociology, with being a subject in the drama rather than a witness. . . . I realize that beyond the rolls of film and the few good pictures, the demands of my project and my confusion about its meaning, is the wish to take photography literally. To stop time. I want my parents to live forever. [2]

Sultan photographed his parents as they went about their lives—post-corporate retirement for his father and entrepreneurial home-selling for his mother—against the quintessential backdrop of the American dream: a ranch house in the suburbs, a heated garage, and wall-to-wall carpeting. Accompanying the photographs, their voices fill the pages and wall spaces of the project as they contemplate their current relationship to one another:

> So your mother is my best friend, but the truth is, that trust is a fragile thing and can be easily broken. Our real problem is how I get irritated and how that can escalate.[3]

> Really, sometimes he can be very sweet, but other times I feel that I have to tiptoe around him, that any moment he'll turn on me. You know that look of his, it burns right through you.[4]

Sultan himself also enters the dialogue, discussing the project and the different narratives of their shared history with his father:

> There are no clear lines—I don't know where you stop and I start. And it's crossed my mind that perhaps I'm out to justify my own life, my choices, by questioning yours.

> You worry too much. I'm really happy to help you with your project. Seriously. I just wanted you to know that for the most part that's not me I recognize in those pictures.[5]

These voices work with and against the photographs, sometimes confirming the apparent reality of the pictures and sometimes contradicting their purported documentary truth. Or is it the reverse? Perhaps it is the photographs that corroborate or complicate one person's recollection. *Pictures from Home*, as a revision of one family's record, deftly navigates the elusive breach between fact and fiction in both its images and its narrative.

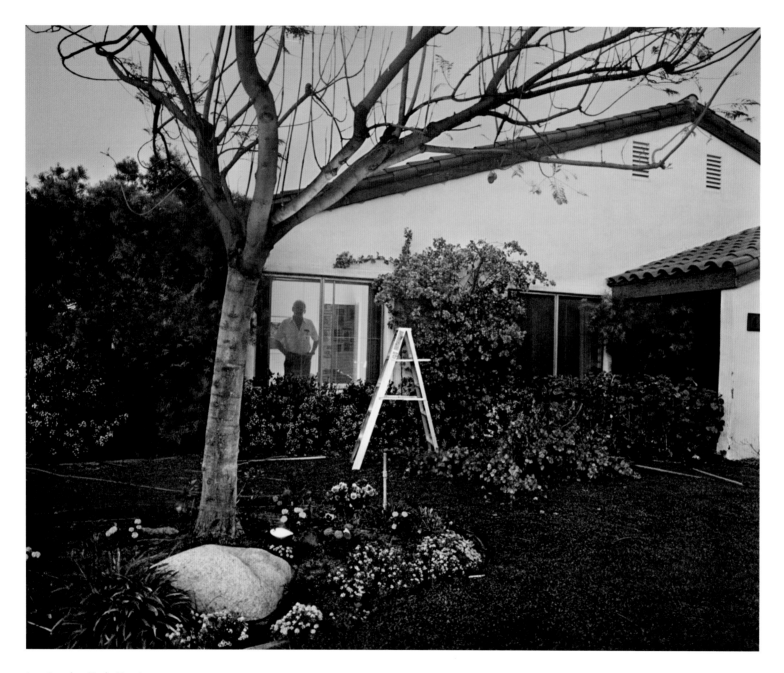

Los Angeles, Early Evening, 1986

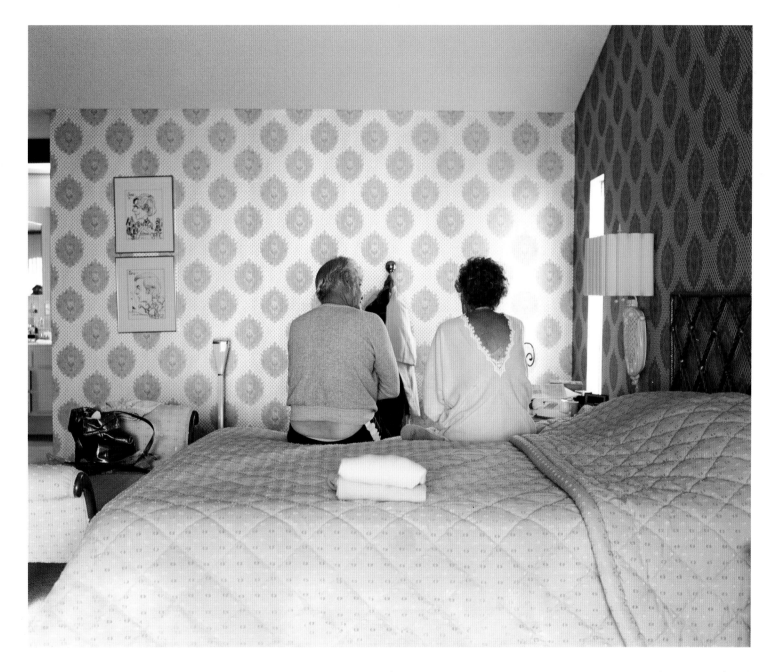

cat. 170

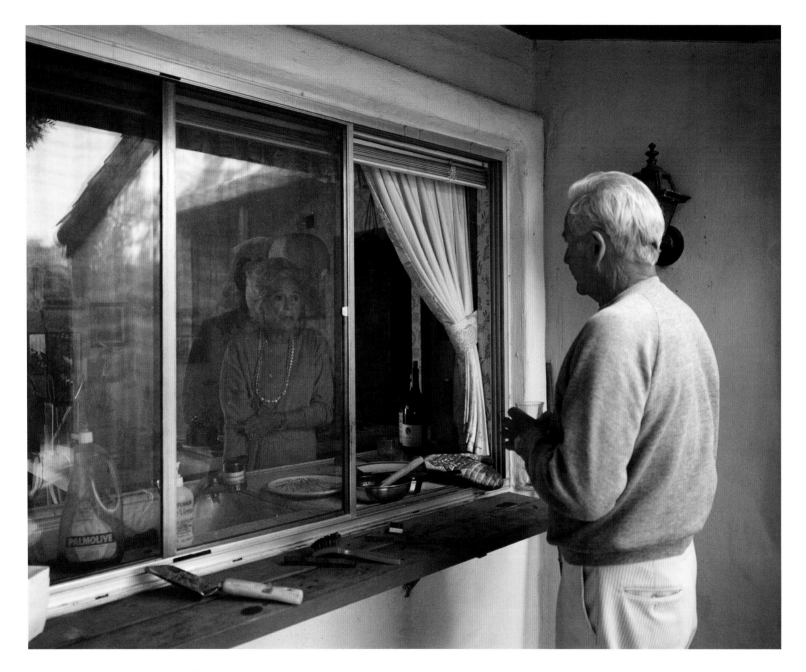

Conversation through Kitchen Window, 1986

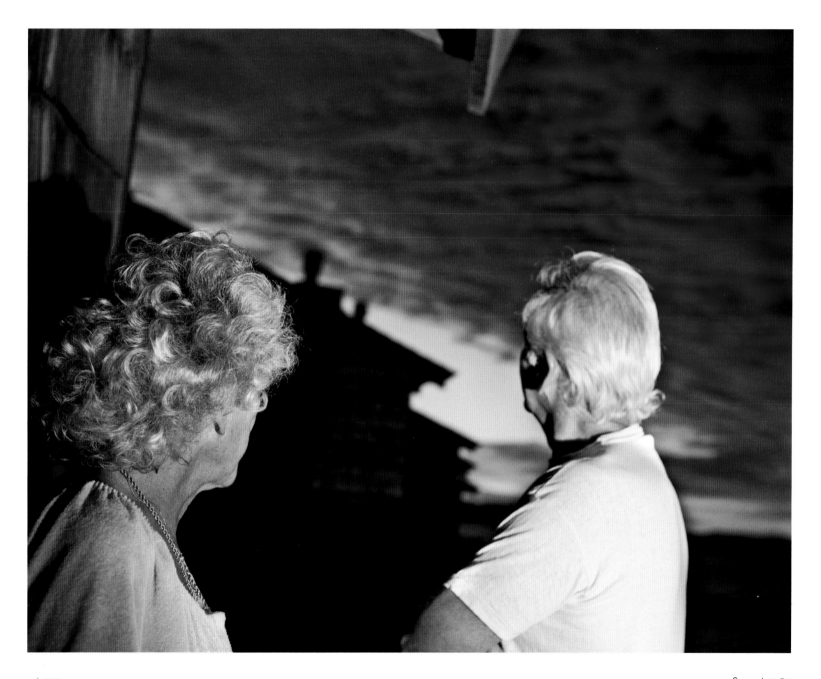

Sunset, 1989

Untitled Home Movie Stills, 1984–91

Untitled Home Movie Stills, 1984–91

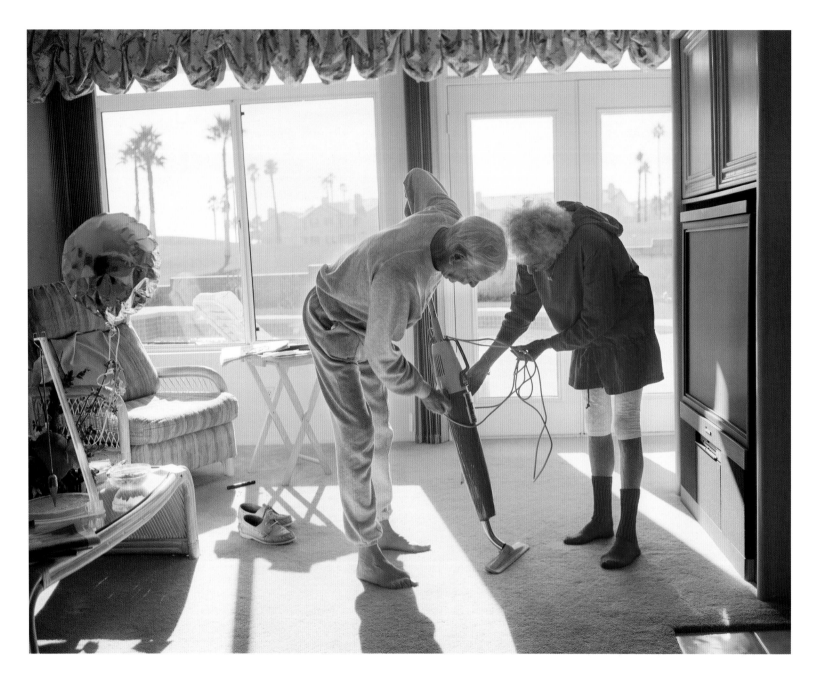

Vacuuming, 1991

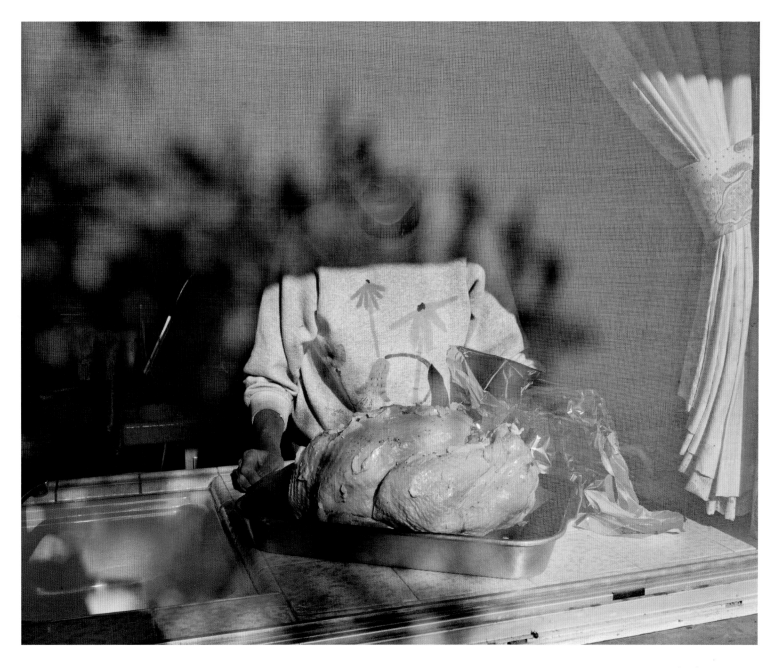

Thanksgiving, 1985

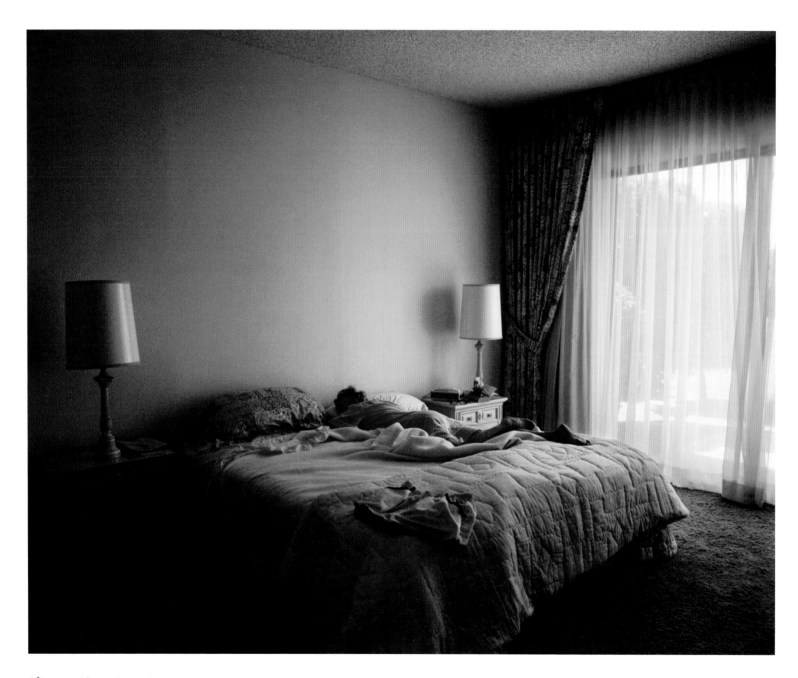

Afternoon Nap, 1987

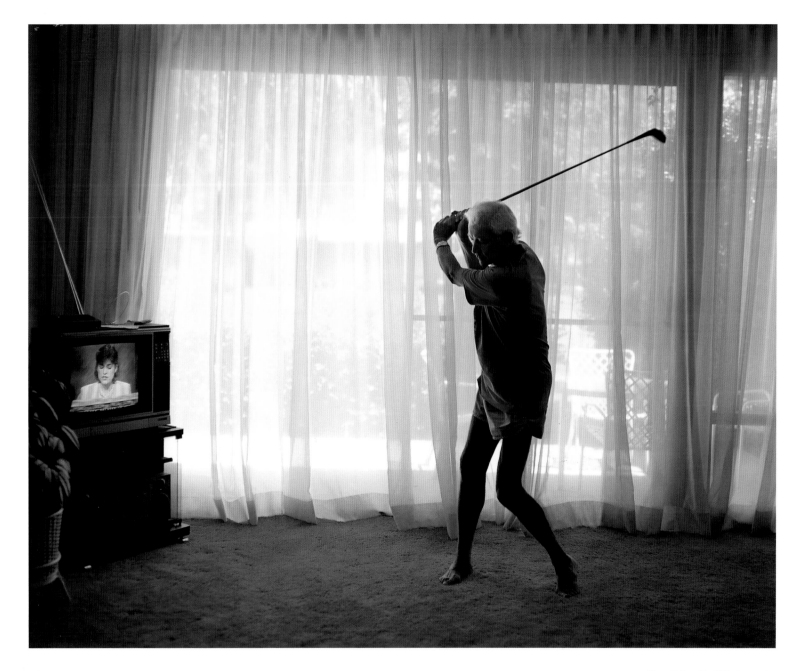

Practicing Golf Swing, 1986

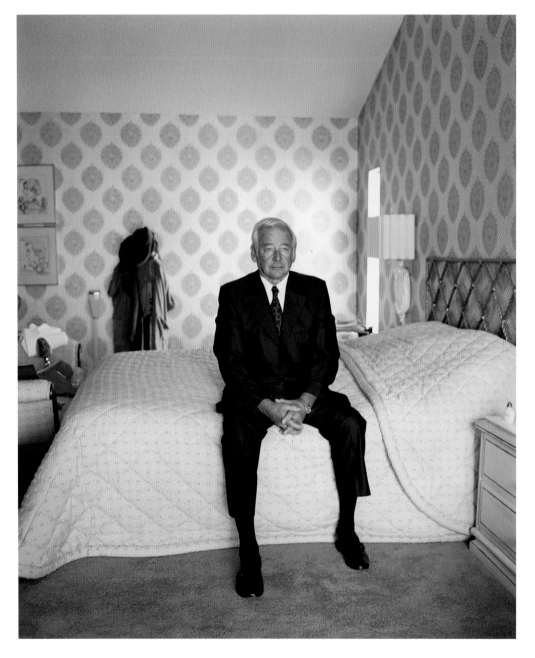

Dad on Bed, 1984

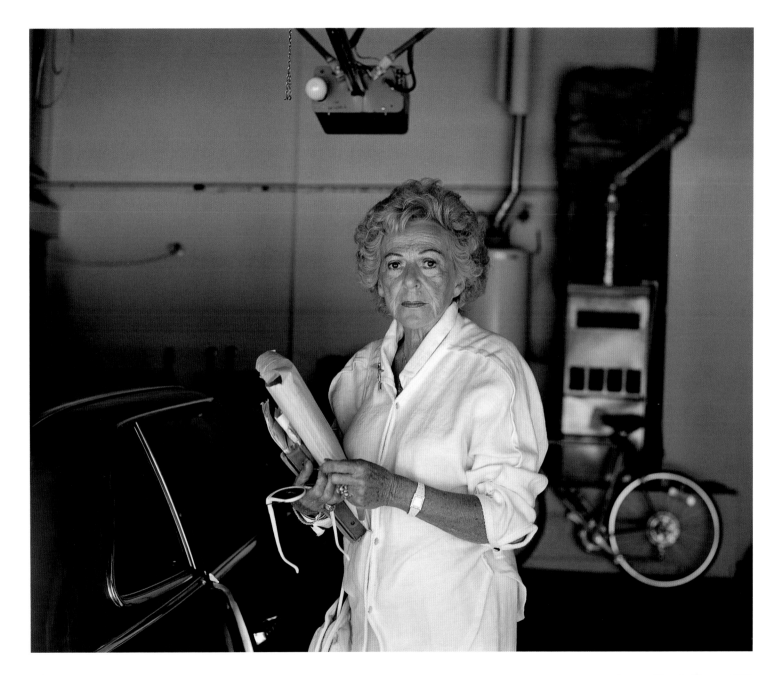

Mom in Garage, 1988

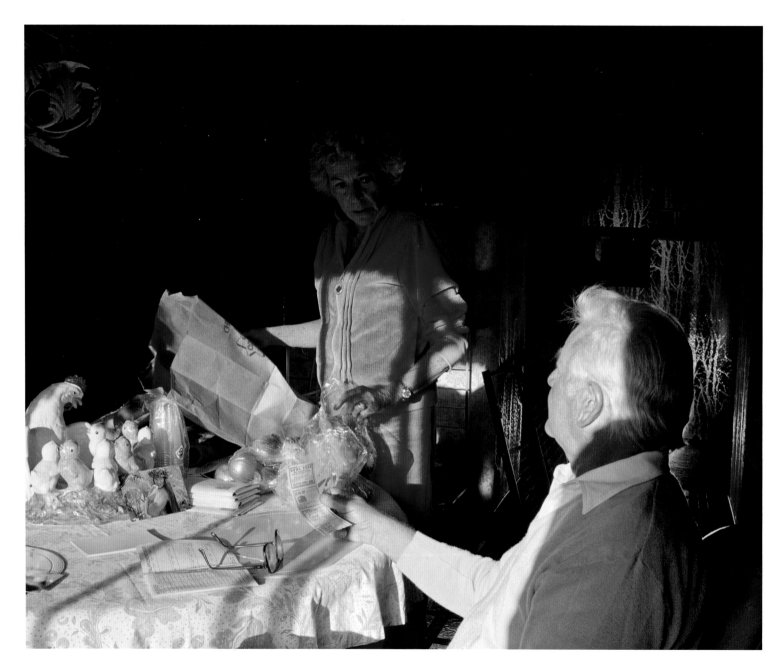

Argument Kitchen Table, 1985

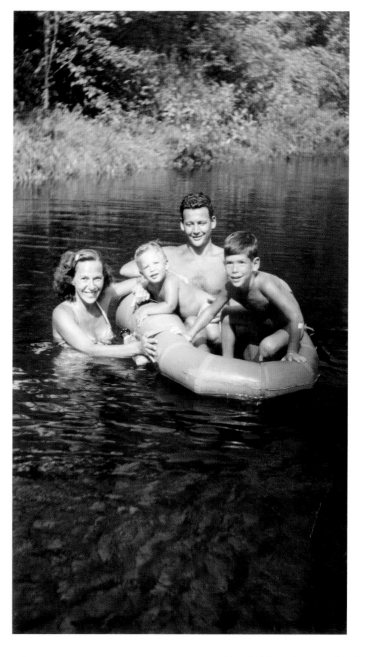

Untitled Snapshot, 1947/91

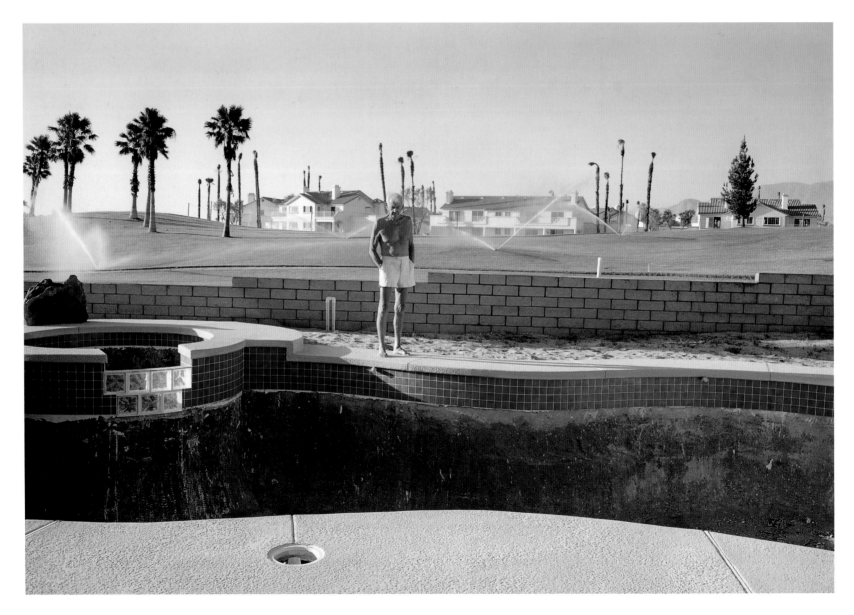

Empty Pool, 1991

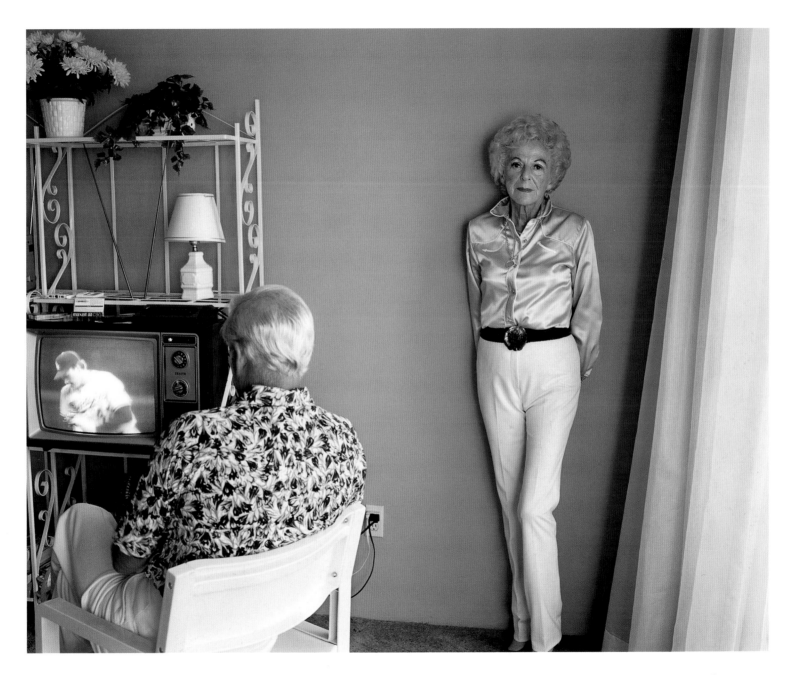

Mom Posing for Me, 1984

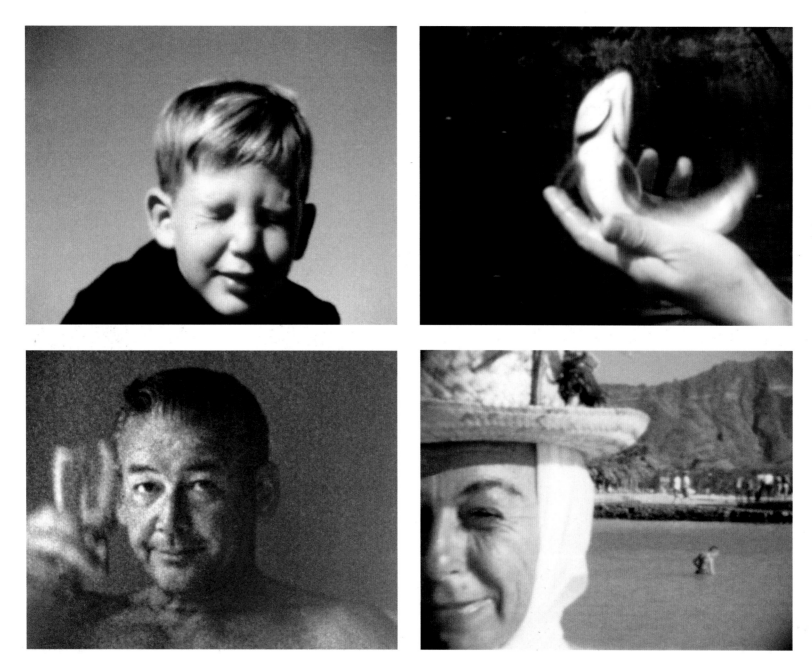

Untitled Home Movie Stills, 1984–91

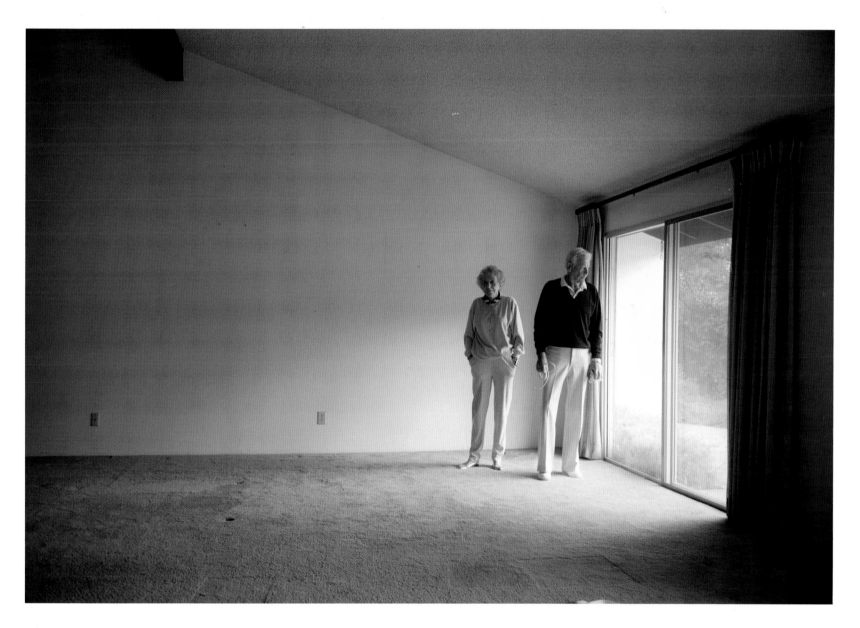

Moving Out, 1988

essay notes

1 Italo Calvino, "The Adventures of a Photographer," trans. William Weaver, Archibald Colquhoun, and Peggy Wright; repr. in *The Short Story and Photography, 1880s–1980s: A Critical Anthology* (University of New Mexico Press, 1998), p. 180.

2 Portraits were decidedly *not* among the possible uses itemized in a report to the French government announcing the invention of the daguerreotype; see Alan Trachtenberg's *Classic Essays on Photography* (Leete's Island Books, 1980), pp. 15–25. William Henry Fox Talbot, however, foresaw the possibility for portraiture with his technique; see his 1839 essay "Some Account of the Art of Photogenic Drawing," in Vicki Goldberg, *Photography in Print: Writings from 1816 to the Present* (Simon and Schuster, 1981), p. 42.

3 Letter to Mary Russell Mitford, quoted in "A Brief Anthology of Quotations," in Susan Sontag, *On Photography* (Farrar, Straus and Giroux, 1977), p. 183.

4 Most photographic portraits from this period are highly prescribed, professionally posed images in which the sitter's likeness, status, and self-presentation are paramount concerns, as they had been in painted portraits at least since the Renaissance. See Julia Hirsch, *Family Photographs: Content, Meaning and Effect* (Oxford University Press, 1981), p. 15.

5 This figure accounts for inflation based on the Consumer Price Index.

6 Douglas R. Nickel, *Snapshots: The Photography of Everyday Life, 1888 to the Present*, exh. cat. (San Francisco Museum of Modern Art, 1998), p. 11.

7 For more on the snapshot's original derivation from a hunting term, see ibid., p. 9.

8 See Nickel (note 6) and Laurie Novak's website *Collected Visions* (http://cvisions.cat.nyu.edu), both of which testify to the endurance of snapshot conventions.

9 Pierre Bourdieu, *Photography: A Middle-brow Art*, trans. Shaun Whiteside (1965; repr. Stanford University Press, 1990), p. 24.

10 See Georgia O'Keeffe, "Introduction," in *Georgia O'Keeffe: A Portrait by Alfred Stieglitz* (Metropolitan Museum of Art, 1978), n.pag.

11 Callahan's most intense period of photographing Eleanor was from the 1940s through the 1960s. See James Adler, "Harry and Eleanor," *Newsletter of the Friends of Photography* 36 (1984), p. 12.

12 See Britt Salvesen, *Harry Callahan: The Photographer at Work*, exh. cat. (Center for Creative Photography, 2006), p. 34.

13 For the complete range of thematic categories, see Edward Steichen, *The Family of Man*, exh. cat. (1955; repr. Museum of Modern Art/Harry N. Abrams, 1996).

14 Emmet Gowin, "Introduction," in *Emmet Gowin*, exh. cat. (Philadelphia Museum of Art, 1990), p. 10.

15 Nicholas Nixon, *Family Pictures: Photographs by Nicholas Nixon* (Smithsonian Institution Press, 1991), p. 6.

16 Sixty-two artists are reproduced in the catalogue and over seventy were included in the exhibition. Peter Galassi, *Pleasures and Terrors of Domestic Comfort*, exh. cat. (Museum of Modern Art, 1991).

17 Larry Sultan, *Pictures from Home* (Harry N. Abrams, 1992), p. 18.

18 Again, Calvino perfectly captured the nature of these oversights: "Your choice [of what to photograph] isn't only photographic; it is a choice of life, which leads you to exclude dramatic conflicts, the knots of contradiction, the great tensions of will, passion, aversion. So you think you are saving yourselves from madness, but you are falling into mediocrity." Calvino (note 1), p. 180.

19 Roland Barthes, *Camera Lucida: Reflections on Photography* (Hill and Wang, 1981).

20 Barthes described this distinction with specific examples: a host of compelling images by various photographers; and a snapshot of his own recently deceased mother as a young girl. So intense, certain, and personal is his reaction to the latter that he chose not to publish it in *Camera Lucida*. Although a photograph by Robert Mapplethorpe or Richard Avedon might similarly affect Barthes and his audience, they could never share this quality of photography before the snapshot of his mother. See ibid., pp. 65–82, 98–99.

portfolio **notes**

Tina Barney:

[1] Tina Barney, Visiting Artists Program lecture, School of the Art Institute of Chicago, Oct. 20, 2004.

[2] Barney has only revealed that she chose the bathroom precisely "because it was intimate." Andy Grundberg, "Tina's World: In Search of the Honest Moment," *New York Times*, Apr. 1, 1990, p. 39.

[3] Tina Barney and Andy Grundberg, *Tina Barney Photographs: Theater of Manners* (Scalo, 1997), p. 10.

Philip-Lorca diCorcia:

[1] DiCorcia has said: "I started with the working assumption that meaning is fluid and truth is mutable. . . . [T]he relation of images to one another is narrative and fictive and disingenuous and completely true to nothing but itself." Philip-Lorca diCorcia, "A Storybook Life" (artist's statement, Pace/MacGill Gallery, 2003).

[2] Other scholars have made reference to the fairytale fiction suggested by some of his photographs. Peter Galassi has described another group of diCorcia's images as "so primal that they read like fables." See Peter Galassi, *Philip-Lorca diCorcia* exh. cat. (Museum of Modern Art, 1995), p. 6.

[3] DiCorcia has likened this sureness about the reality of photographs to a "foreign language that everyone thinks he speaks." Quoted in ibid., p. 10.

Nan Goldin:

[1] Nan Goldin interview with Scott Rothkopf, *The Harvard Advocate* 134 (Spring 1999).

[2] Nan Goldin, *Nan Goldin: I'll Be Your Mirror*, exh. cat. (Whitney Museum of American Art/Scalo, 1996), p. 256.

Sally Mann:

[1] Sally Mann, *Immediate Family* (Aperture, 1992), n.pag.

[2] Ibid.

[3] The 1990 seizure of Jock Sturges's studio by the Federal Bureau of Investigation and the obscenity trial of Robert Mapplethorpe's photographs in Cincinnati are two examples of an atmosphere that intensified anxious responses to the publication and exhibition of *Immediate Family*. For an excellent sense of the stakes, intensity, and reach of the controversy at that time, see Richard Bolton, ed., *The Culture Wars: Documents from the Recent Controversies in the Arts* (New Press, 1992).

[4] The Mann children have played so central a role in determining this project that they effectively overturned their mother's 1991 decision not to publish *Immediate Family*. Nevertheless, many publications, including art journals, simply refused to reprint images that they felt too easily suggested violence and sexuality. For lengthier discussions of some of these issues, see Anne Higonnet, *Pictures of Innocence: The History and Crisis of Ideal Childhood* (Thames and Hudson, 1998).

Larry Sultan:

[1] Larry Sultan, *Pictures from Home* (Harry N. Abrams, 1992), p. 18.

[2] Ibid.

[3] Irving Sultan, quoted in ibid., p. 104.

[4] Jean Sultan, quoted in ibid., p. 105.

[5] Larry and Irving Sultan in conversation, quoted in ibid., p. 114.

exhibition catalogue

tina barney

born 1945, New York, New York

While taking photography classes in Sun Valley, Idaho, in the early 1970s, Tina Barney began photographing her family during vacations to her native New England. Initially using a 35-millimeter camera and black-and-white film, she soon switched to large-format cameras and color film. This approach lengthened the working process and allowed her to render the relations of her friends and family in greater detail. The resulting images straddle the boundary of the staged moment and the impromptu observation. The exhibition *Big Pictures by Contemporary Photographers* (1983), at the Museum of Modern Art, acknowledged that Barney and others were producing work on a scale comparable to paintings. Her first monograph, *Friends and Relations* (1991), was followed by *Theater of Manners* (1997), which brought together photographs of her family with more formal portraits and a series of nudes. In 1996 Barney began photographing the upper echelons of European society, publishing the work in *The Europeans* (2005). More recently, she has turned her attention to the skilled laborers in her hometown of Watch Hill, Rhode Island.

Unless otherwise noted, the following works are all chromogenic color prints; 121.9 x 152.4 cm (48 x 60 in.); courtesy of Janet Borden, Inc.

1. **Sunday New York Times**, 1982
 (see p. 20)

2. **The Skier**, 1986
 76.2 x 101.6 cm (30 x 40 in.)
 (see p. 21)

3. **Jill and Polly in the Bathroom**, 1987
 The Art Institute of Chicago, restricted gift of the Auxiliary Board, Susan and Doug Lyons, and Robert H. Glaze; Mary and Leigh Block Fund, 2005.91
 (see p. 22)

4. **Marina's Room**, 1987
 117.8 x 149.9 cm (46 3/8 x 59 in.)
 Courtesy of the Museum of Contemporary Photography, Columbia College, Chicago
 (see p. 32)

5. **Sheila and Moya**, 1987
 76.2 x 101.6 cm (30 x 40 in.)
 (see p. 30)

6. **Lil and Jill**, 1988
 (see p. 27)

7. **Jill and the TV**, 1989
 (see p. 28)

8. **Phil and I**, 1989
 (see p. 25)

9. **Sheila in the Garden**, 1989

10. **Tim, Phil, and I**, 1989
 (see p. 24)

11. **Jill and I**, 1990
 (see p. 23)

12. **Thanksgiving**, 1992
 (see p. 26)

13. **The Trustee and the Curator**, 1992
 76.2 x 101.6 cm (30 x 40 in.)
 (see p. 29)

14. **Jill and I**, 1993
 (see p. 37)

15. **Tim, Philip, and Phil**, 1993
 (see p. 35)

16. **Philip and Philip**, 1996
 101.6 x 76.2 cm (40 x 30 in.)
 (see p. 36)

17. **Sheila and the Squash**, 1996
 101.6 x 76.2 cm (40 x 30 in.)
 (see p. 34)

18. **Marina and Peter**, 1997
 94 x 73.7 cm (37 x 29 in.)
 Courtesy of the Museum of Contemporary Photography, Columbia College, Chicago
 (see p. 33)

19. **Marina in the Yellow Dress**, 1997
 101.6 x 76.2 cm (40 x 30 in.)

20. **Moya and the Peach**, 1997
 101.6 x 76.2 cm (40 x 30 in.)
 (see p. 31)

philip-lorca **dicorcia**
born 1951, Hartford, Connecticut

Philip-Lorca diCorcia pursued photography at the School of the Museum of Fine Arts in Boston (diploma 1975, post-graduate certificate 1976). He went on to study photography with Tod Papageorge at Yale University (MFA 1979), where he was introduced to the work of street photographer Garry Winogrand and conceptual artists such as Ed Ruscha. In 1990 diCorcia initiated a project titled *Hustlers*, which consists of portraits of male prostitutes, drifters, and drug addicts, whom he paid to pose for him. In 1993 diCorcia began *Streetwork*, a series that combines elements of street photography with theater. In 2001 he released *Heads*, a series in which he surreptitiously photographed passers-by, who were lit by hidden flashes. His most recent work, *Lucky Thirteen*, a series of dramatic portraits of exotic dancers, debuted at the Carnegie International in 2004. He has also received grants from the National Endowment for the Arts and a Guggenheim Fellowship.

All works are from the series *A Storybook Life* (1975–99; compiled 2003); 76 chromogenic color prints, mounted to Plexiglas, listed here in the sequence established by the artist; paper size each 40.6 x 50.8 cm (16 x 20 in.); courtesy of Pace/MacGill Gallery, New York.

21. **Ventura**, 1991

22. **Hartford**, 1979
(see p. 40)

23. **Singapore**, 1993

24. **Hartford**, 1980
(see p. 41)

25. **Oklahoma City**, 1999

26. **New York City**, 1983

27. **DeBruce**, 1999
(see p. 42)

28. **New York City**, 1984
(see p. 43)

29. **New York City**, 1985

30. **Truro**, 1988

31. **Salonika**, 1980

32. **Los Angeles**, 1981

33. **Norfolk**, 1979

34. **Willowemoc**, 1988

35. **Tokyo**, 1993

36. **New Haven**, 1978

37. **Laguiole**, 1992

38. **Los Angeles**, 1990

39. **Los Angeles**, 1997

40. **Willowemoc**, 1987

41. **New Haven**, 1979

42. **Naples**, 1994
(see p. 44)

43. **Kansas City**, 1980

44. **Singapore**, 1993

45. **Hartford**, 1978
(see p. 45)

46. **Ouarzazte**, 1991
(see p. 46)

47. **Wellfleet**, 1992
(see p. 47)

48. **Los Angeles**, 1980

49. **Atlantic Ocean**, 1975

50. **Singapore**, 1993

51. **Skopelos**, 1993

52. **Wellington**, 1996

53. **Los Angeles**, 1980

54. **Bethel**, 1992

55. **Long Beach**, 1980

56. **Wellfleet**, 1993

57. Hartford, 1977

58. Berlin, 1991

59. Hartford, 1980
 (see p. 48)

60. Hartford, 1980
 (see p. 49)

61. Kent, 1979

62. Skopelos, 1994

63. Cairo, 1988

64. Wellfleet, 1993

65. Los Angeles, 1997
 (see p. 50)

66. Hartford, 1979
 (see p. 51)

67. Salonika, 1980

68. New Haven, 1978

69. Naples, 1995

70. Hartford, 1978

71. New York City, 1982

72. New York City, 1999

73. Formentera, 1994

74. Ventura, 1991

75. Los Angeles, 1990

76. Los Angeles, 1997

77. New York City, 1989

78. Coney Island, 1994
 (see p. 52)

79. Los Angeles, 1992

80. Naples, 1995

81. Paris, 1998

82. Milan, 1985

83. Los Angeles, 1981

84. Los Angeles, 1981

85. Naples, 1995

86. New York City, 1996

87. DeBruce, 1999
 (see p. 53)

88. Berlin, 1997

89. New York City, 1996

90. New York City, 1984
 (see p. 54)

91. Antipaxos, 1980
 (see p. 55)

92. Wellfleet, 1993

93. Tehran, 1995

94. Hartford, 1978

95. Hartford, 1989
 (see p. 56)

96. Hartford, 1980
 (see p. 57)

nan **goldin**
born 1953, Washington, D.C.

Nan Goldin began photographing at age fifteen, creating black-and-white images of drag queens that were exhibited in 1973. After receiving a BFA from the School of the Museum of Fine Arts, Boston, in 1977, Goldin moved to New York City in 1978 and began what would become *The Ballad of Sexual Dependency*, a photographic diary of her life on the lower east side of Manhattan. Initially shown as a slideshow in underground clubs and cinemas, *The Ballad* was included in the Whitney Biennial in 1985 and published as a book in 1986. In 1991 Goldin published *Cookie Mueller*, which chronicled her best friend's battle with and eventual death from AIDS. The Whitney Museum of American Art organized Goldin's mid-career exhibition, *I'll Be Your Mirror*, in 1996. In recent years, Goldin has continued to photograph her own life, incorporating an increasing number of landscapes and still lifes. In 2004 Goldin debuted *Sisters, Saints, and Sibyls*, a multimedia installation that explores the institutionalization and suicide of her sister, Barbara, alongside Goldin's own hospitalization and the mythical history of Saint Barbara.

97. **Self-portrait**, 1978–94/95
 16 silver-dye bleach prints; 92 x 138 cm (36 1/4 x 54 1/2 in.). The Art Institute of Chicago, partial gift of Dorie Sternberg, 2005.22
 (see p. 61)

98. **The Ballad of Sexual Dependency,**
 1979–2001
 Multimedia installation of 720 color slides and a programmed soundtrack; running time 43 minutes. Courtesy of Nan Goldin and Matthew Marks Gallery, New York

The following stills are reproduced in the catalogue:
a. **Empty beds, Lexington, Massachusetts**, 1979
 (see p. 60)

b. **The Hug**, 1980
 (see p. 64)

c. **Suzanne crying, NYC**, 1985
 (see p. 63)

d. **Greer and Robert on the bed, NYC**, 1982
 (see p. 62)

e. **The Parents' wedding photo, Swampscott, MA**, 1985
 (see p. 65)

f. **Cookie at Tin Pan Alley, NYC**, 1983
 (see p. 66)

g. **Cookie and Vittorio's wedding, NYC**, 1986
 (see p. 68)

Unless otherwise noted, the following works are all silver-dye bleach prints; image size 65.4 x 97.8 cm (25 3/4 x 38 1/2 in.); courtesy of Nan Goldin and Matthew Marks Gallery, New York.

99. **Cookie with me after I was punched, Baltimore, MD**, 1986
 (see p. 67)

100. **Cookie at Vittorio's casket, NYC,**
 September 16, 1989

101. **Cookie in her casket, NYC,**
 November 15, 1989
 (see p. 69)

102. **Jimmy Paulette and Tabboo! in the bathroom, NYC**, 1991

103. **Siobhan in the shower, NYC**, 1991

104. **Gilles and Gotscho, Paris**, 1992–93/95
 5 silver-dye bleach prints; 382 x 101.6 cm (150 x 40 in.). Courtesy Marieluise Hessel Collection on permanent loan to the Center for Curatorial Studies, Bard College, Annandale-on-Hudson, New York

a. **Gilles and Gotscho in my hotel room, Paris**, 1992

b. **Gilles and Gotscho at home, Paris**, 1992

c. **Gotscho in the movie theater, Paris**, 1993

d. **Gilles' arm, Paris**, 1993

e. **Gotscho kissing Gilles, Paris**, 1993
 (see p. 70)

105. Amanda on my Fortuny, Berlin, 1993

106. Max at Sharon's apartment under
 photograph of his mother Cookie,
 NYC, 1996
 (see p. 72)

107. Pawel laughing on the beach,
 Positano, 1996
 (see p. 73)

108. Simon in the snow at dawn,
 Christmas, Umeå, Sweden, 1997

109. Valérie and Gotscho embraced,
 Paris, 1999
 (see p. 71)

110. Decorated bed, Suite 22, Roosevelt
 Hospital, NYC, 2000
 (see p. 74)

111. First Love: Simon and Jessica, 2001
 3 silver-dye bleach prints; 228.6 x 101.6 cm
 (90 x 40 in.)

 a. Simon and Jessica looking at each other
 through light, Paris

 b. Simon and Jessica on the train sleeping,
 Paris–Avignon

 c. Simon and Jessica kissing in the pool, Avignon
 (see p. 75)

112. Jabalowe under his mosquito net,
 Barat, Luxor, Egypt, 2003
 (see p. 76)

113. Simon in my bed, Paris, 2004

114. Self-portrait at New Year's Eve,
 Malibu, 2006
 (see p. 77)

sally **mann**
born 1951, Lexington, Virginia

For the past three decades, Sally Mann has drawn inspiration from her family and the land. The photographs in her early publication *At Twelve* (1988) explore the coming of age of girls in and around her native Rockbridge County, Virginia. In the mid-1980s, Mann began photographing her children and her husband in images that garnered a great deal of national attention and debate. In 1991 Mann's work was included in the Whitney Biennial, and the next year her family photographs were published in *Immediate Family*. Inspired by a cache of historic, glass-plate negatives of familiar local places in the mid-1970s, Mann adopted the antiquarian wet collodion process herself. This work was published in *Motherland* (1997) and *Deep South* (2005). In the publication *What Remains* (2003), Mann has combined these evocative landscapes with new portraits of her children and haunting still lifes. Mann has been awarded three grants by the National Endowment for the Arts, as well as a Guggenheim Fellowship.

The following works are from the series *Immediate Family* (1985–92). Unless otherwise noted, all are gelatin silver prints; 50.8 x 61 cm (20 x 24 in.); courtesy of Gagosian Gallery, New York.

115. Emmett's Bloody Nose, 1985

116. Jessie Bites, 1985
 (see p. 80)

117. Jessie's Cut, 1985

118. **Popsicle Drips**, 1985
61 x 50.8 cm (24 x 20 in.)
The Art Institute of Chicago, Smart Family
Foundation Fund, 2005.430
(see p. 82)

119. **Virginia in the Sun**, 1985
The Art Institute of Chicago, restricted gift of
the Friends of Photography, 1994.43

120. **Easter Dress**, 1986
The Art Institute of Chicago, restricted gift of
Lucia Woods Lindley and Daniel A. Lindley, Jr.,
2000.38

121. **He Is Very Sick**, 1986

122. **The Ditch**, 1987
The Art Institute of Chicago, gift of Sally Mann
and Edwynn Houk Gallery, 2000.41
(see p. 83)

123. **The Last Time Emmett Modeled
Nude**, 1987

124. **The Wet Bed**, 1987

125. **Emmett Afloat**, 1988

126. **Emmett, Jessie, and Virginia**, 1989
20.3 x 25.4 cm (8 x 10 in.)
(see p. 96; cat. only)

127. **Hangnail**, 1989

128. **Holding Virginia**, 1989
61 x 50.8 cm (24 x 20 in.)
The Art Institute of Chicago, restricted gift of
Robin and Sandy Stuart, 2005.24
(see p. 86)

129. **Last Light**, 1990
The Art Institute of Chicago, gift of Edwynn
Houk, New York, 2005.35
(see p. 84)

130. **Three Generations**, 1990

131. **At Warm Springs**, 1991
60.2 x 50.7 cm (23 3/4 x 19 15/16 in.)
The Art Institute of Chicago, Mary and Leigh B.
Block Endowment, 2000.39

132. **Dog Scratches**, 1991
The Art Institute of Chicago, "For Anstiss,"
restricted gift of Ronald Krueck, 2005.23

133. **Larry Shaving**, 1991
(see p. 88)

134. **Sunday Funnies**, 1991

135. **Virginia at Prayer**, 1991
(see p. 87)

136. **Crossing the Maury**, 1992
(see p. 91)

137. **Picnic**, 1992
(see p. 85)

138. **Raising Her Hand**, 1992
(see p. 81)

139. **JoJo's Discovery**, 1994

Unless otherwise noted, the following works are all
gelatin silver prints; 76.2 x 96.5 cm (30 x 38 in.); cour-
tesy of Gagosian Gallery, New York.

140. **Blue Hills**, 1993
(see p. 90)

141. **Canal**, 1994

142. **Niall's River**, 1994

143. **Ben Salem**, 1995
(see p. 89)

144. **Right Angle**, 1995

145. **Dark Mist**, 1996
(see p. 93)

146. **Virginia Kudzu**, 1996
(see p. 92)

Unless otherwise noted, the following works are all
gelatin silver prints; 127 x 101.6 cm (50 x 40 in.); cour-
tesy of Gagosian Gallery, New York.

147. **Emmett 42**, 2004

148. **Emmett 45**, 2004
(see p. 94)

149. **Jessie 10**, 2004

150. **Jessie 25**, 2004
(see p. 95)

151. **Triptych**, 2004
3 gelatin silver prints; 127 x 304.8 cm
(50 x 120 in.)
(see p. 97)

 a. Virginia

 b. Emmett

 c. Jessie

152. **Virginia 9**, 2004
(see p. 94)

153. **Virginia 35**, 2004

154. **Virginia 37**, 2004
(see p. 95)

larry **sultan**
born 1946, Brooklyn, New York

After receiving an MFA from the Art Institute of San Francisco in 1973, Larry Sultan collaborated with Mike Mandel on conceptual and public art projects that explore photography's ability to furnish truth about history and human experience. Together, the pair used a grant from the National Endowment for the Arts to produce *Evidence* (1977), in which they grouped black-and-white photographs culled from the files of laboratories, police departments, and government agencies. These purportedly objective photographs become ambiguous and peculiar when stripped of their captions. In 1991 Sultan completed *Pictures from Home*, which brings together photographs he made of his aging parents with family snapshots, home movie stills, and excerpts from their conversations and his journal. His most recent body of work, *The Valley* (2004), focuses on the banal domestic details of the world of adult movies filmed in the suburban homes in the San Fernando Valley, the area where Sultan grew up.

All works are from the series *Pictures from Home* (1982–91). Unless otherwise noted, all are chromogenic color prints; 76.2 x 91.4 cm (30 x 36 in.).

155. **Untitled Snapshot**, 1947/91
Gelation silver print; 17.8 x 10.2 cm (7 x 4 in.)
Courtesy of Larry Sultan
(see p. 113)

156. **Dad on Bed**, 1984
Haluk Soykan, promised gift to the Art Institute of Chicago
(see p. 110)

157. **Mom Posing for Me**, 1984
73 x 99 cm (28 3/4 x 39 in.)
The Art Institute of Chicago, restricted gift of Reva and David Logan, 2005.107
(see p. 115)

158. **Nightstand**, 1984
Haluk Soykan, promised gift to the Art Institute of Chicago

159. **Untitled Home Movie Stills**, 1984–91
Four digital prints; each 81.3 x 101.6 cm (32 x 40 in.)
Ralph and Nancy Segall, promised gift to the Art Institute of Chicago; Haluk Soykan, promised gift to the Art Institute of Chicago
(see p. 104)

160. **Untitled Home Movie Stills**, 1984–91
Four digital prints; each 81.3 x 101.6 cm (32 x 40 in.)
Ralph and Nancy Segall, promised gift to the Art Institute of Chicago; Jeanne and Richard S. Press, promised gift to the Art Institute of Chicago; Haluk Soykan, promised gift to the Art Institute of Chicago
(see p. 105)

161. **Untitled Home Movie Stills**, 1984–91
Four digital prints; each 81.3 x 101.6 cm (32 x 40 in.)
Jeanne and Richard S. Press, promised gift to the Art Institute of Chicago; Haluk Soykan, promised gift to the Art Institute of Chicago
(see p. 116)

162. **Argument Kitchen Table**, 1985
Ralph and Nancy Segall, promised gift to the
Art Institute of Chicago
(see p. 112)

163. **Business Page**, 1985
Jeanne and Richard S. Press, promised gift to
the Art Institute of Chicago

164. **Reading in Bed**, 1985
Haluk Soykan, promised gift to the Art
Institute of Chicago

165. **Thanksgiving**, 1985
Haluk Soykan, promised gift to the Art
Institute of Chicago
(see p. 107)

166. **Convention Documents**, 1986
Each 20.3 x 25.4 cm (8 x 10 in.)
Courtesy of Larry Sultan

167. **Conversation through Kitchen
Window**, 1986
Haluk Soykan, promised gift to the Art
Institute of Chicago
(see p. 102)

168. **Los Angeles, Early Evening**, 1986
101.6 x 127 cm (40 x 50 in.)
Haluk Soykan, promised gift to the Art
Institute of Chicago
(see p. 100)

169. **Practicing Golf Swing**, 1986
Ralph and Nancy Segall, promised gift to the
Art Institute of Chicago
(see p. 109)

170. **Sitting on Bed**, 1986
Haluk Soykan, promised gift to the Art
Institute of Chicago
(see p. 101)

171. **Afternoon Nap**, 1987
50.8 x 61 cm (20 x 24 in.)
Jeanne and Richard S. Press, promised gift to
the Art Institute of Chicago
(see p. 108)

172. **Talking through Car Window**, 1987
Ralph and Nancy Segall, promised gift to the
Art Institute of Chicago

173. **Mom in Garage**, 1988
Ralph and Nancy Segall, promised gift to the
Art Institute of Chicago
(see p. 111)

174. **Moving Out**, 1988
50.8 x 61 cm (20 x 24 in.)
Ralph and Nancy Segall, promised gift to the
Art Institute of Chicago
(see p. 117)

175. **Sunset**, 1989
Haluk Soykan, promised gift to the Art
Institute of Chicago
(see p. 103)

176. **Mom in Pool**, 1990
Jeanne and Richard S. Press, promised gift to
the Art Institute of Chicago

177. **Cadillac**, 1991
Ralph and Nancy Segall, promised gift to the
Art Institute of Chicago

178. **Empty Pool**, 1991
101.6 x 127 cm (40 x 50 in.)
Ralph and Nancy Segall, promised gift to the
Art Institute of Chicago
(see p. 114)

179. **Vacuuming**, 1991
Ralph and Nancy Segall, promised gift to the
Art Institute of Chicago
(see p. 106)

acknowledgments

My first and foremost thanks go to Tina Barney, Philip-Lorca diCorcia, Nan Goldin, Sally Mann, and Larry Sultan; without their enthusiasm and advice this project would never have been realized. I would also like to recognize the support received from Janet Borden and Matthew Whitworth at Janet Borden, Inc.; Jeffrey Peabody and Callen Bair at Matthew Marks Gallery; Carolyn Francis at Gagosian Gallery; Peter MacGill and Caroline Dowling at Pace/MacGill Gallery; Julie Castellano at Edwynn Houk; and Stephen Wirtz Gallery. The Museum of Contemporary Photography at Columbia College, Chicago, and the Marieluise Hessel Collection, New York, generously lent works from their collections that enriched both the catalogue and exhibition.

A project of this scale would not have been possible without the commitment of Andrea Moran and the Evening Associates Board of the Art Institute of Chicago. I thank the Robert Mapplethorpe Foundation for their additional support of *So the Story Goes*. My heartfelt thanks extends to those donors who understood how acquisitions by these five talents would impact the legacy of our collection: Ralph and Nancy Segall; Haluk Soykan; Dorie Sternberg; the Smart Family Foundation; the Auxiliary Board of the Art Institute of Chicago; Jeanne and Richard S. Press; Edwynn Houk; Reva and David Logan; Anstiss and Ronald Krueck; Robin and Sandy Stuart; Lucia Woods Lindley and Daniel A. Lindley, Jr.; Susan and Doug Lyons; Robert H. Glaze, and the Committee on Photography. In celebration of *So the Story Goes*, our first-ever benefit gala was ably chaired by Bradford L. Ballast, Karen Frank, and Elizabeth Bryan Seebeck and benefited from the generosity of LaSalle Bank, Lead Sponsor; Phillips de Pury and Company, Supporting Sponsor; and the Gala Steering Committee.

I wish to thank President and Eloise W. Martin Director James Cuno and Curator of Photography David Travis, for entrusting me with such a wonderful opportunity so soon after my arrival at the Art Institute. Assistant Curator Elizabeth Siegel has been a constant colleague, offering reserves of patience and support in equal measure with doses of good humor and advice. Amanda Freymann of the Publications Department championed this catalogue and its production. Elizabeth Stepina ensured it was all I hoped it would be, providing so much more than edits, and Karin Kuzniar designed a book that beautifully suits the aims and ideas of the art presented within. Others at the Art Institute deserve special acknowledgment for coordinating countless details and generally making such a large project seem anything but unwieldy: Joe Cochand, Lisa D'Acquisto, Gregory Harris, Sarah Hoadley, James Iska, Chai Lee, Jeffrey Nigro, Therese Peskowits, Douglas Severson, Newell Smith, and Karin Victoria. I am also grateful to colleagues, in Chicago and beyond, who provided encouragement of the curatorial kind: Whitney Bradshaw, Julian Cox, Lisa Dorin, Natasha Egan, Carol Ehlers, Peter Galassi, Karen Irvine, Anne Lyden, Weston Naef, James Rondeau, Kate Ware, and Sylvia Wolf.

In a project featuring art inspired by personal experience, I break with protocol and conclude by thanking those friends and family who have inspired me these past two years. Greg Lucas merits special mention for first imagining a book with my name on the spine. And I thank Darby English for being an unwavering reminder that— as it does in the self-timer pictures we love to make together—everything has a way of working out.

Katherine A. Bussard
Assistant Curator of Photography